POSTCARD HISTORY SERIES

Around Lexington, Virginia

POSTCARD HISTORY SERIES

Around Lexington, Virginia

Richard Weaver

Copyright © 1999 by Richard Weaver
ISBN 978-0-7385-8970-1

Published by Arcadia Publishing
Charleston, South Carolina

Printed in the United States of America

Library of Congress Catalog Card Number: 98-83151

For all general information contact Arcadia Publishing at:
Telephone 843-853-2070
Fax 843-853-0044
E-Mail sales@arcadiapublishing.com
For customer service and orders:
Toll-Free 1-888-313-2665

Visit us on the Internet at www.arcadiapublishing.com

CONTENTS

Acknowledgments		6
Postcard History		7
Introduction		9
1.	The Westminster Abbey of the Confederacy	11
2.	The Athens of the Old South	15
3.	The West Point of the South	27
4.	General Lee's College	37
5.	The Little Pittsburgh of the South	49
6.	"One of the Seven Natural Wonders of the World"	53
7.	Rockbridge Back Roads	59
8.	The Girls' Schools	63
9.	The Road to Roanoke and Salem	71
10.	The Road to the Homestead	83
11.	Papa's Footsteps	91
12.	Landmarks	95
13.	Lee and Washington	101
14.	Greetings from Virginia	109
15.	Lore	121
Index		127

Acknowledgments

I'd like to thank my Mom and Dad, Pam and Brian Weaver, for sending me to Washington and Lee and sending themselves to Parents' Weekend to enjoy Lexington for themselves. And they were the ones who got me started collecting these old postcards.

Brian Shaw, Barbara Brown, and Vaughan Stanley at Washington and Lee kindly granted me permission to use some postcards in the university's collection. Kirk Susong offered me great advice on how to structure the book. Mame Warren and Henry Harris gave me the cover suggestion. Mary Laura and Diane Jacob at Virginia Military Institute answered many of my questions, as did Bill Ruble, Betty-Jo Wheeler at the Mayflower, Dave Parker at Natural Bridge, Rhonda Widener at Emory and Henry College, Katie Smith at the Bath County Historical Society, and Dave Blount at Sweet Briar College. Also thanks to the residents of the Brickhouse for the study space, and the brothers of Sigma Nu, Lambda chapter for their hospitality.

At Arcadia Publishing, I would like to thank my editor Mark Berry, publicist Sara Long, and copy editor Ingrid Patterson for all of their hard work in seeing this book to its completion.

POSTCARD HISTORY

Sending a postcard can accomplish two purposes: informing the recipient of the writer's location and disposition, and sending a picture that will publicize a place or perhaps promote more tourism there.

In the heyday of postcards there were hundreds of companies that printed them. Some hired photographers to capture the highlights and historic landmarks of towns and regions. These black-and-white photographs were then tinted with color. A beautiful sunset could be inserted, even a stray tree moved to a more appropriate location. The finished product cost about half a penny to print.

The railroads in the region often provided photographs for the printers to use. The printers got free material to reproduce for their own profit; the railroads got publicity in exchange. The postcard titled "Is Two Over One Railroad Fare?" is a good example of such a trade-off.

All of the images in this book come from my personal collection of postcards, unless indicated otherwise. Some of these cards appear to be "homemade," in that the postcard writers took the picture, printed it on stiff paper, and mailed it. They may be the most revealing of all the images.

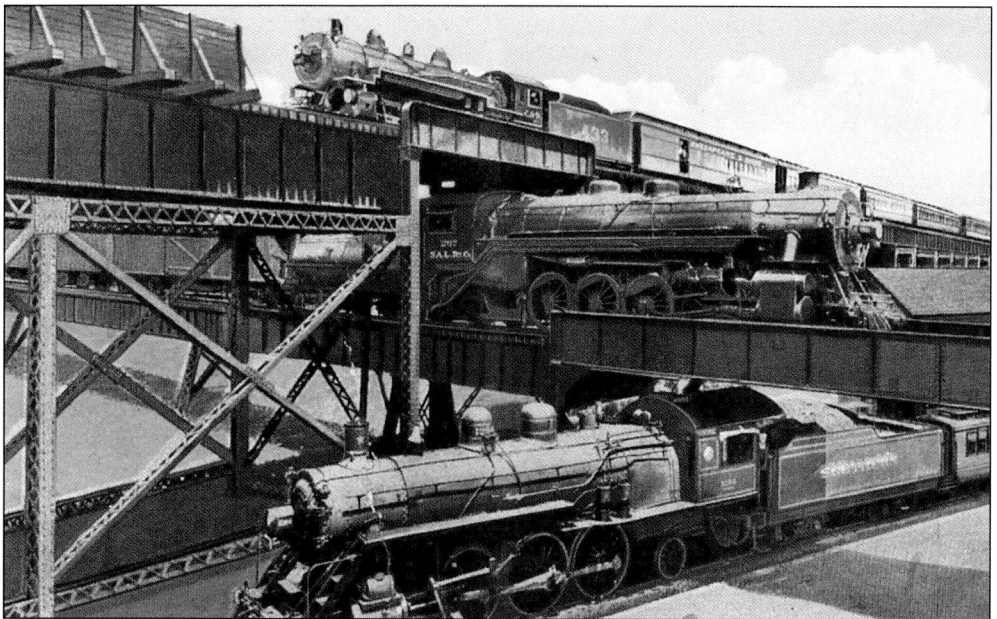

"IS TWO OVER ONE RAILROAD FARE?" (SIXTEENTH AND DOCK). RICHMOND, VIRGINIA, APRIL 3, 1933. "This unique photograph presents to view the only point in the world where three trunk line trains may cross each other, at the same time and over their separate tracks. At the top is shown a passenger train of the C&O Railway leaving Richmond for the upper James River Valley; just beneath is a train of the S.A.L. Railway leaving the Main Street (Union) Depot for the South, and on the ground a train of the Southern Railway coming into Richmond from West Point on the York River."

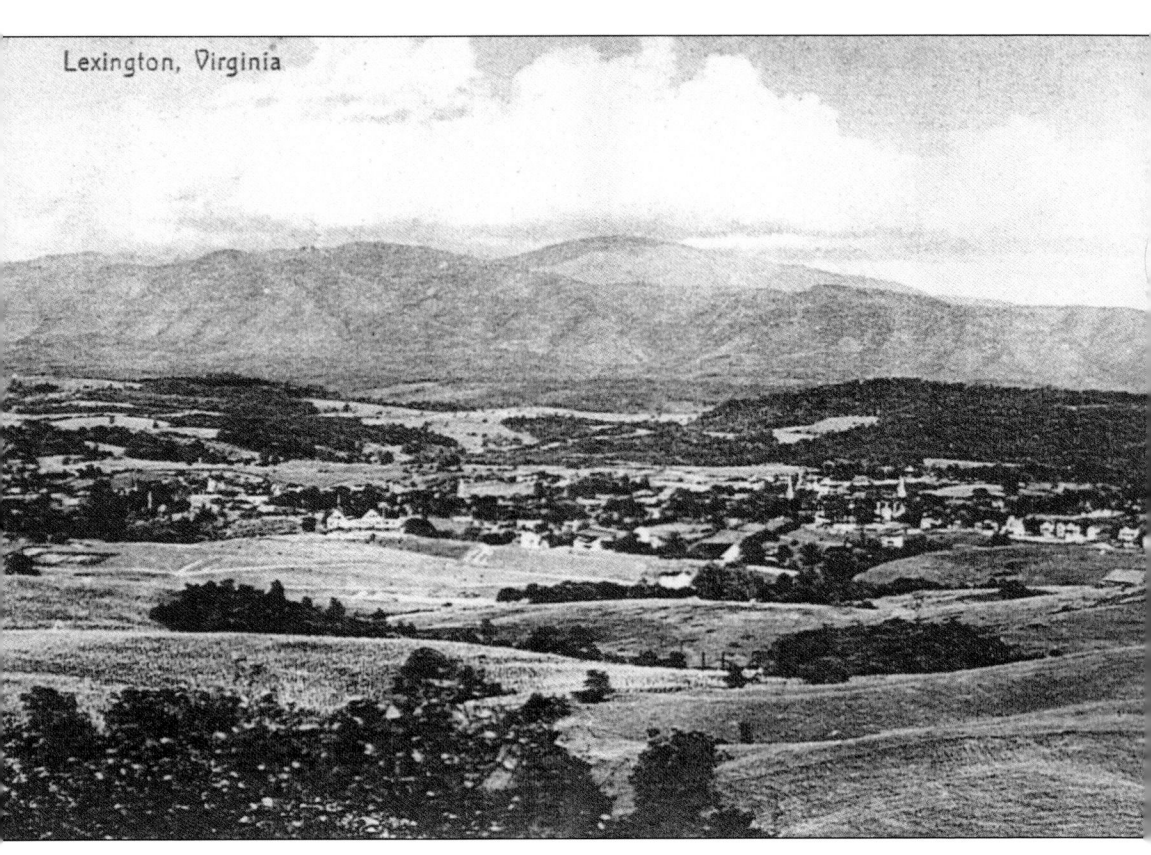

INTRODUCTION

I live in Lexington, Virginia. Though I have resided elsewhere since 1996, I come back to Lexington when I'm on vacation. I like buying groceries at Harris Teeter and reading the *News Gazette*, which arrives in the mail intact with the Harris Teeter circular each week. When I am in town I like to drive the windy back roads, on 39 or 60, or both on a good day. I also look for pictures and mementoes of Lexington in the stores to decorate my home.

When I first considered writing this book, I was concerned that perhaps I was dwelling too much in the past. Most everyone enjoys their college experience and the place where they had it, but Lexington is more than a meeting place for my Washington and Lee friends (I graduated in 1996). I'm at home here, even in summer, when most of the students are gone.

After I applied to Washington and Lee, my high school college counselor told me a story about the first time he went to Lexington. Before he left, he had asked someone for directions to the campus. They had told him: "Look for the building with the white columns." That, of course, describes half the buildings in town. To invent a word, many are "postcardesque." And in searching dusty file cabinets and boxes in antique stores from Texas to Florida to Washington, I have found the postcards that showed other people thought so too.

These postcards bring to mind the many times I've been in these buildings or attended functions or classes there. In the summer of 1992, after I had been admitted to Washington and Lee, I came with my mother and father to have another look at the campus and the city. As we walked along Nelson Street, a white-haired woman approached us. She asked us if we were tourists, and we said "yes," and then she asked if we would help her with something. We crossed the street to Dominion Bank (now First Union), at the corner of Main and Nelson, where the downtown association was dedicating a bench to the tourists visiting Lexington. A few minutes later, the mayor, H.E. "Buddy" Derrick, came along to shake our hands. A photographer from the *News Gazette* took our picture. It could have been the perfect subject of a postcard, with the title: "Friendly Mayor Welcomes Tourists to Lexington."

Writing this book has also been an opportunity for me to walk in the "footsteps" of my family. It took several years for me to fully understand our connection to the area, forged long before I came around. When I drive to Lexington, I pass signs for Independence and Galax, where my family used to go to hunt for antiques during our summer vacations. I would never have guessed one day I would be calling myself a Virginian. I like to think when I return I can also trace my own footsteps, made when I reached personal milestones.

This book is not meant to be "The History of Lexington." I am indebted to books like *Lexington in Old Virginia* by Henry Boley, *General Lee's College* by Ollinger Crenshaw, and *A*

Crowd of Honorable Youths by Thomas W. Davis for the history I've included with my personal comments. In fact, some of the postcards in this book were printed by Boley's bookstore. The content of this book has been driven largely by the selection of images. There is a lot about Lexington that is not in this book.

When captions or portions of captions are in quotation marks, they are either taken from text printed on the card or the message written by the sender. Caption titles either came from the card, or in their absence, I created one to match the scene. I've also indicated postmark dates where applicable. Not all of these cards were sent, though.

I specifically chose *Around Lexington, Virginia* for the title of this book because I believe living there makes residents naturally curious about other parts of the state with a historical or personal connection. In some cases, "Around Lexington" is a geographic term, and in others, it is in spirit.

Richard Weaver

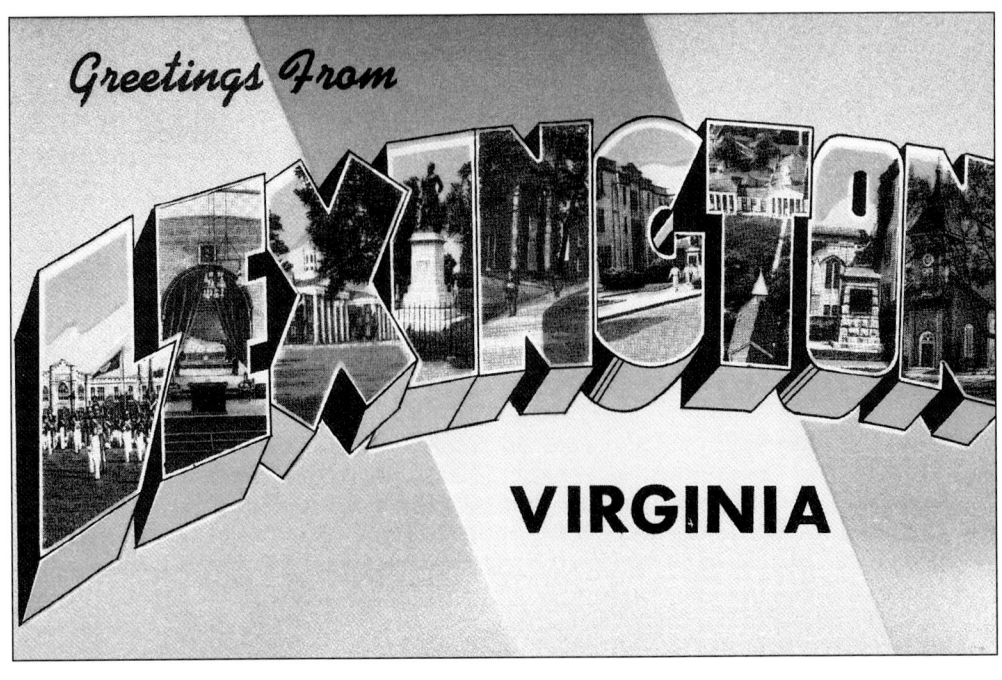

One

THE WESTMINSTER ABBEY OF THE CONFEDERACY

The chapel where Robert E. Lee is buried is the principal draw for many tourists who come to Lexington. Lee had it built in 1867, while he was serving as the president of Washington College (renamed, after his death, Washington and Lee University). Students still meet and speakers still speak and ministers still conduct marriage ceremonies in Lee Chapel. It is alive with activity, just as Lee intended.

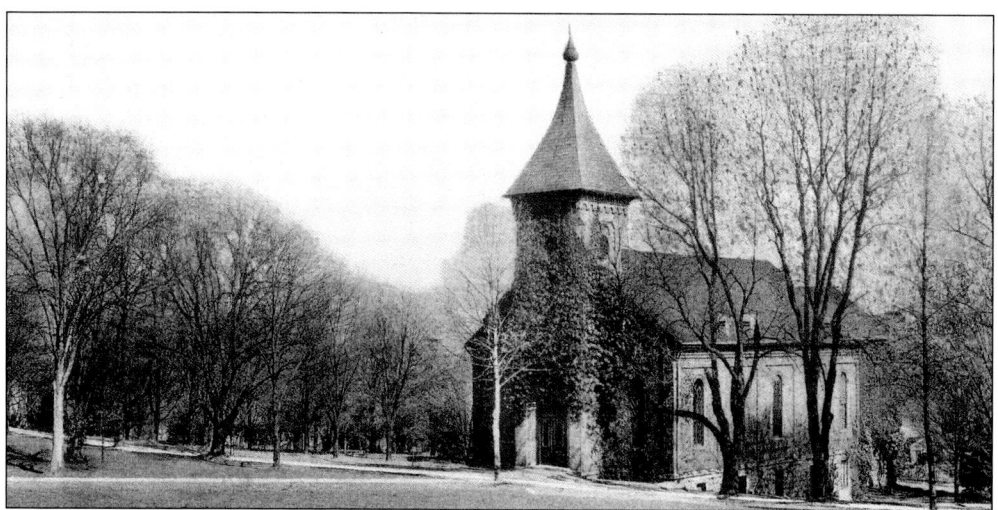

LEE CHAPEL. As the story goes, ivy from Mount Vernon was transplanted to the front of Lee Chapel. The meeting place was restored, fire-proofed, and air conditioned in the early 1960s with a grant from the the Ford Motor Company. A second restoration and a revamped museum were completed in 1998.

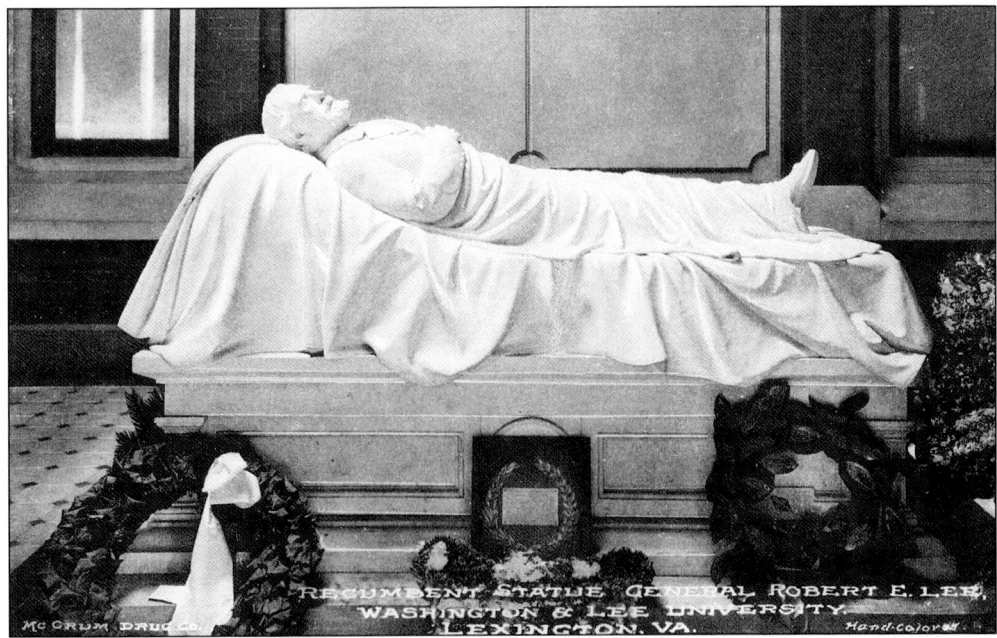

THE RECUMBENT STATUE. This sculpture by Edward Valentine is the centerpiece of Lee Chapel. The general is depicted asleep in camp; Valentine even sculpted the look of fiber in the blanket that covers him. Reproductions of Confederate battle flags hang on the walls of the alcove where the statue rests, and flowers are left near it for occasions like Lee's birthday and the anniversary of his death.

POEM on VALENTINE'S RECUMBENT STATUE of GENERAL ROBERT E. LEE in LEE CHAPEL

LEXINGTON, VIRGINIA

I came to weep at a sculptured tomb,
 But lo! no death was there;
For I saw Life's mystical touch illume
Each shadow of deep, selpulchral gloom
 With light celestial fair.

With light celestial fair, in whose gleam
 My troubled soul grew blest,
As its glory fell on the marble dream,
 Of that sleeper who lay at rest.

—SARAH B. VALENTINE

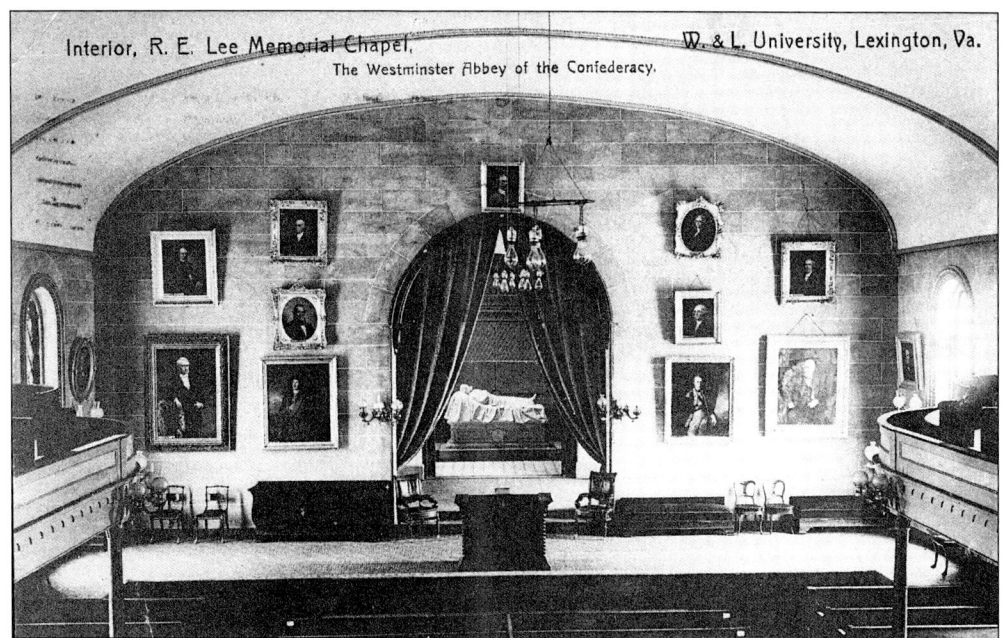

INTERIOR, R.E. LEE MEMORIAL CHAPEL, POSTMARKED NOVEMBER 10, 1905. This postcard, like many others from this period, was made from a photograph by Michael Miley. In many views of the chapel's interior, the paintings on the back wall disappear or move with the years. Now, only two paintings hang there: Charles Willson Peale's portrait of Washington and Theodore Pine's portrait of Lee. They are said to be two of the most valuable possessions of the university.

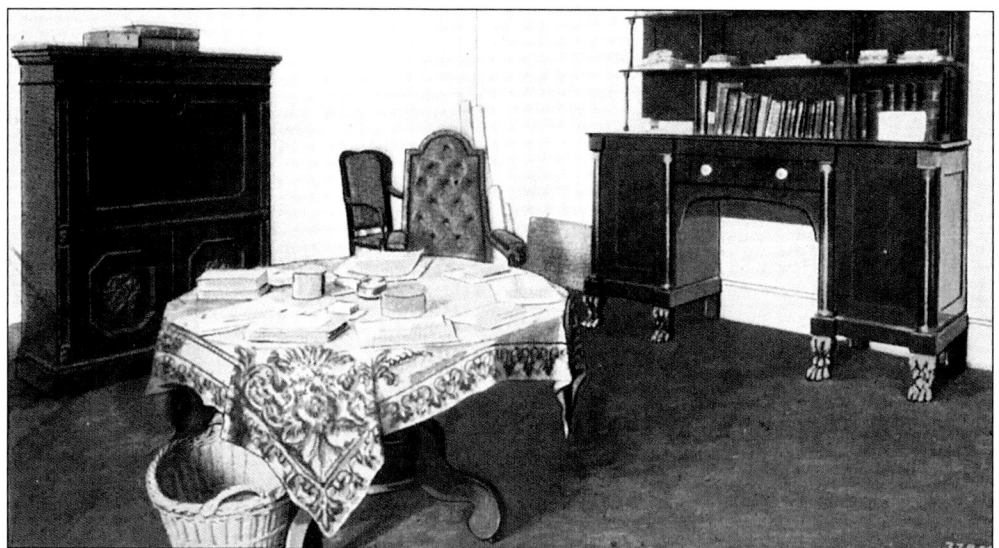

GENERAL LEE'S OFFICE, IN THE CHAPEL WHEN HE WAS PRESIDENT OF WASHINGTON COLLEGE. "General Lee's office substantially as he left it at the time of his death in 1870. Many students received fatherly and friendly advice in this room and it was here that the business of the College was administered." The director of the chapel gave my fraternity brothers and I permission to have our senior picture taken inside the office, which is normally roped off from visitors. It is the college picture I treasure most.

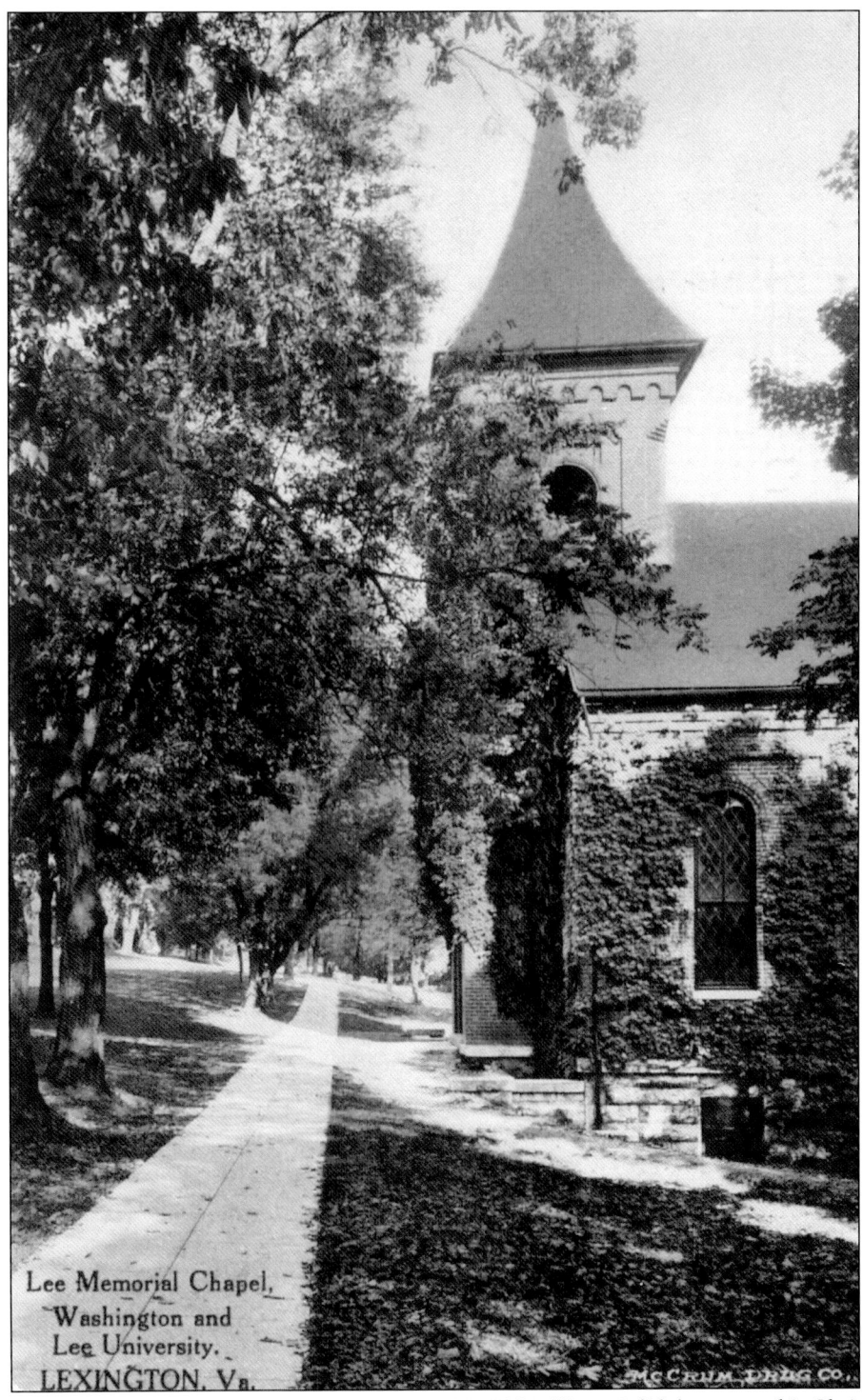

LEE MEMORIAL CHAPEL, POSTMARKED JANUARY 20, 1915. "Sorry I didn't see you this Christmas. This is a beautiful place, don't you think?"

Two

THE ATHENS OF THE OLD SOUTH

Many people have nicknamed Lexington, trying to find something suitably distinctive to make out-of-towners take notice. In 1777, the town was named for the revolutionary Battle of Lexington, which had taken place three years earlier. At that time Lexington contained about 20 acres, and had three streets running long-ways: Randolph, Main, and Jefferson; and three cross-ways: Henry, Washington, and Nelson.

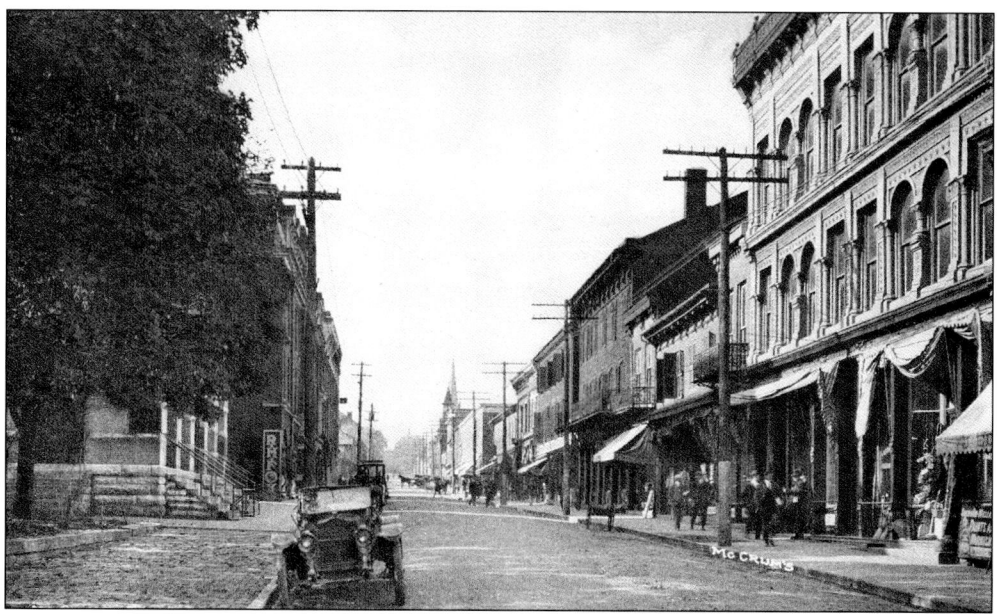

MAIN STREET. There are still places to tie a horse on Main Street. Most of the equine traffic these days is limited to horse-drawn tourist carriages. The sidewalks have been re-bricked and the power lines buried—a model for other small towns looking to preserve their unique characters and attract tourists.

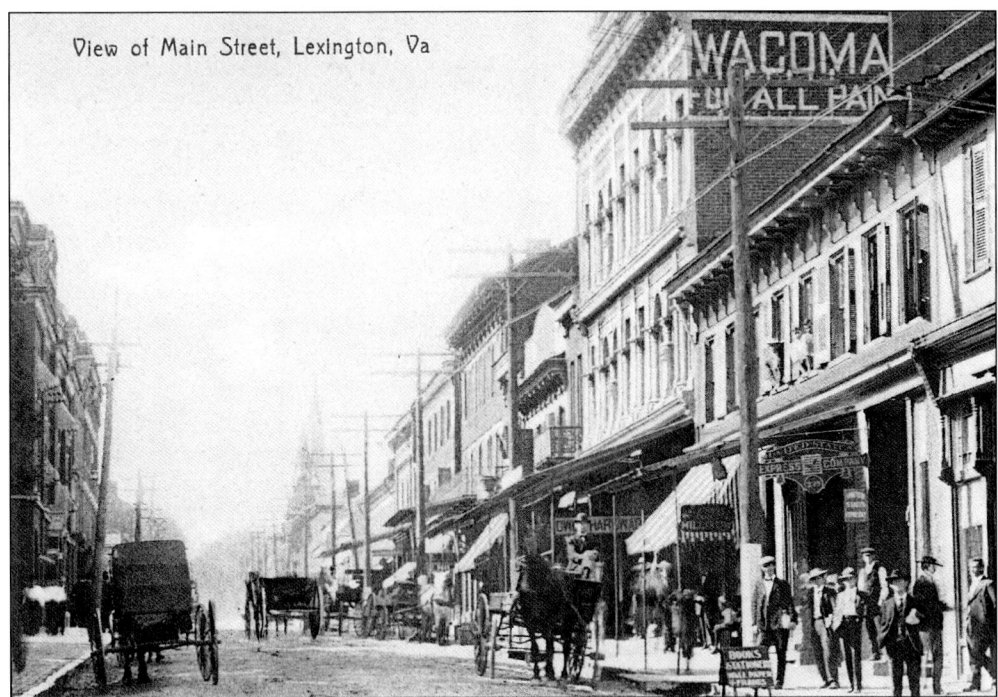

VIEW OF MAIN STREET. Merchants here smartly fill their shops with distinctive "Virginia" and "Lexington" items, and several offer shoppers sips of cider (warm or cold, depending on the season) as they browse. A few of them even have a basket or two of old postcards like these for sale.

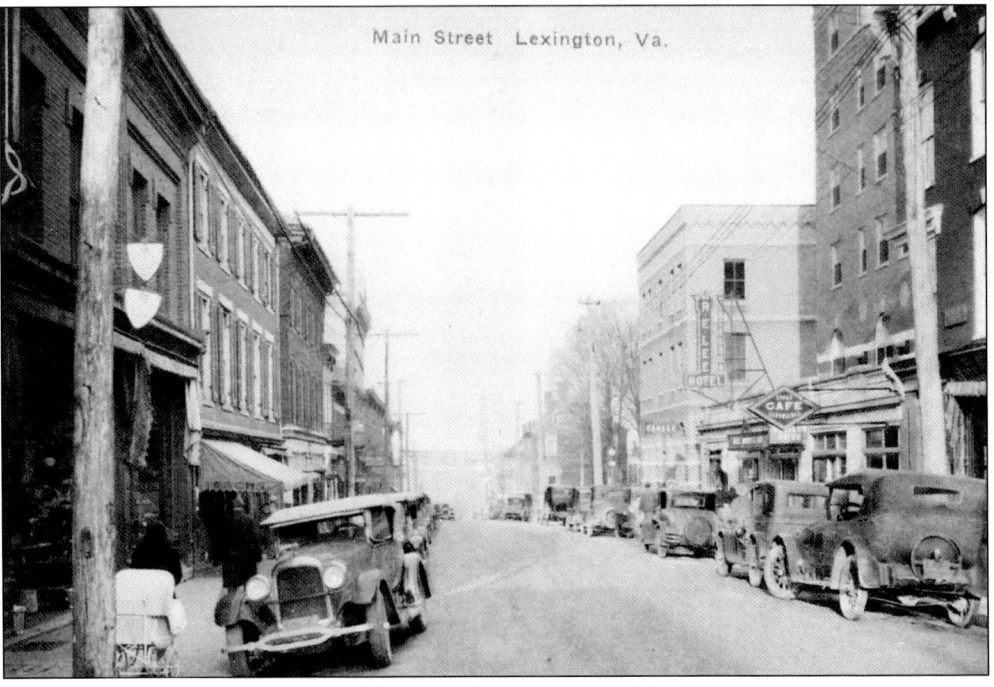

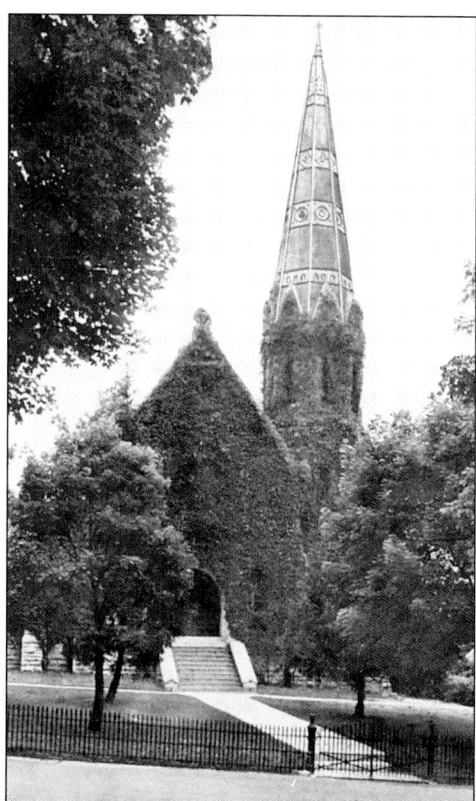

R.E. Lee Memorial Episcopal Church. Students and townspeople worship together at this church, just down Washington Street from Lee's House. The general served on the vestry of Grace Church; at the last vestry meeting before his death in 1870, the group decided to build a new church building. When built, it was named Grace Memorial Church (in honor of Lee), and a few years later, it was given its present name.

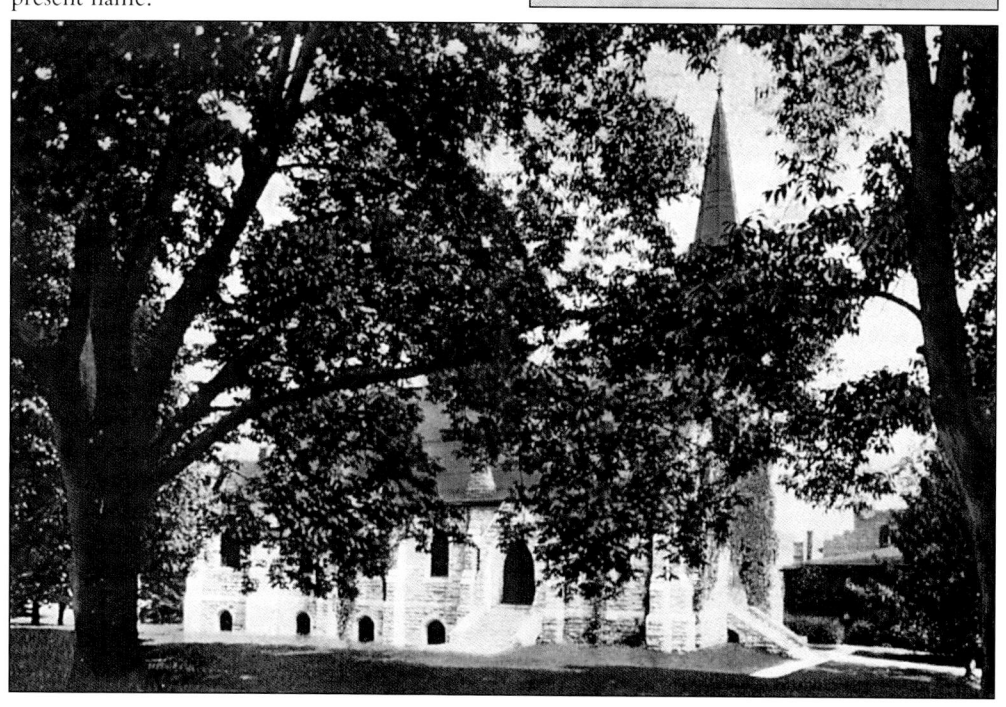

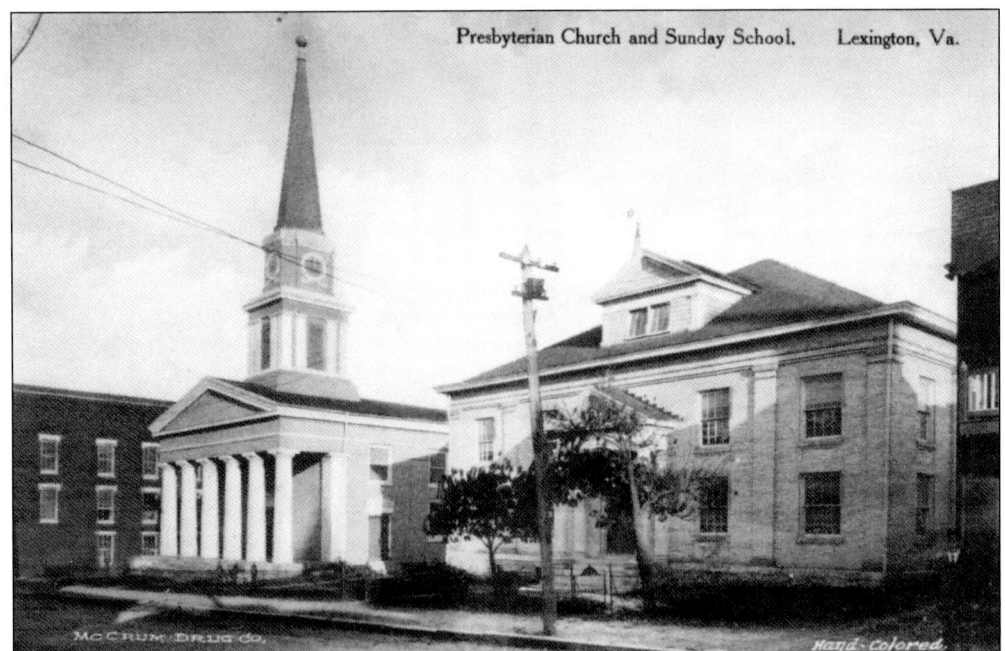

PRESBYTERIAN CHURCH AND SUNDAY SCHOOL. Thomas "Stonewall" Jackson taught Sunday school to local slaves in this church, located on the corner of Main and Nelson Streets. Jackson had joined the church in 1851, when he arrived in Lexington to teach at VMI, and he later served as a deacon. The main building was completed in 1845, and enlarged 50 years later.

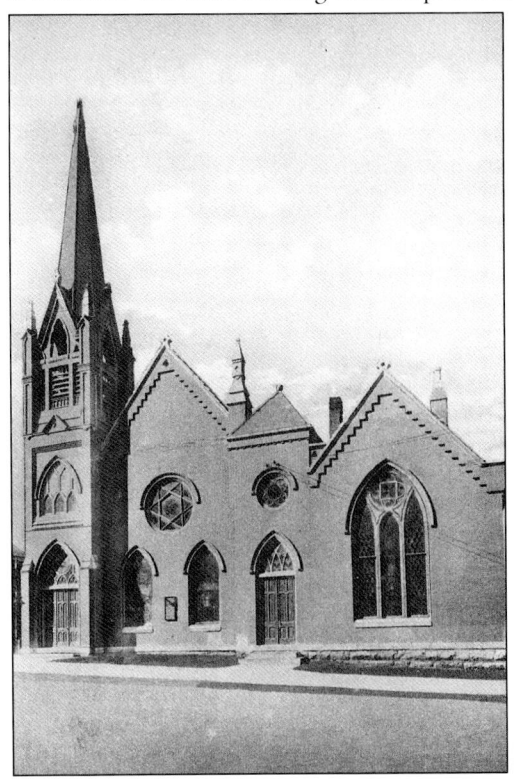

TRINITY METHODIST CHURCH. This house of worship was built in 1926, the second Methodist church on that site on South Main Street. The first, Lexington Methodist, had been dedicated in 1889. Its predecessor was built on Jefferson Street in 1853; for the most part white Methodists worshipped there, beginning in 1864. Lexington's original Methodist church, made of wood, had been located on Randolph Street. It was replaced with a brick church, which the black Methodist congregation used after the whites left. (Courtesy Special Collections, Leyburn Library, Washington and Lee University.)

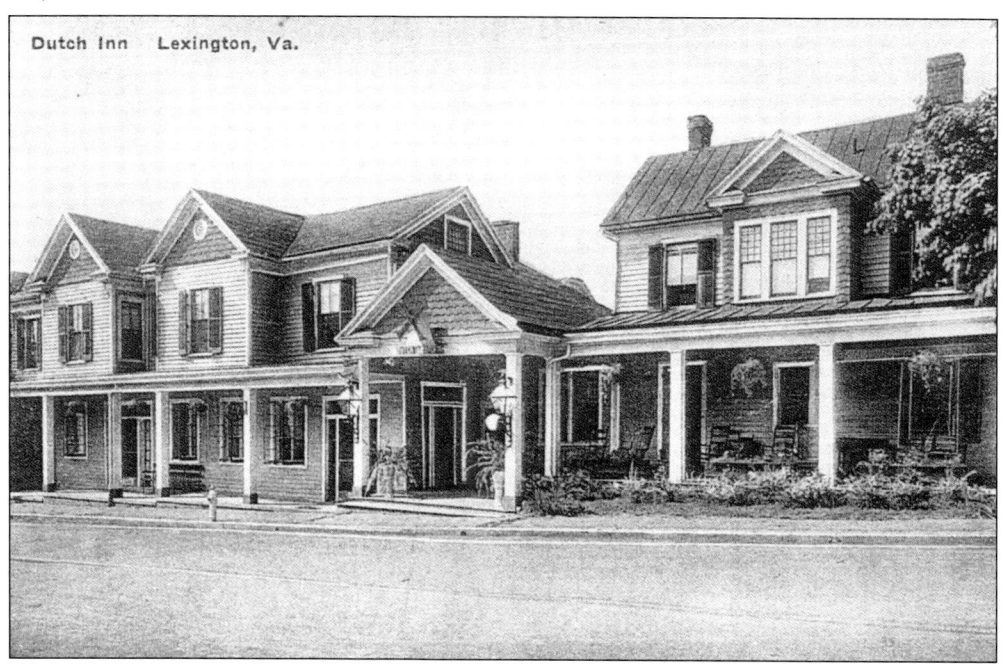

THE DUTCH INN. BOTTOM POSTCARD POSTMARKED JUNE 20, 1930. As of 1985, there had been at least 23 people who owned the buildings that today constitute the Dutch Inn. Occupants have included a hotel, a boardinghouse, a cafeteria, and numerous shops. During World War II, the U.S. Army leased the Dutch Inn to house members of the Women Army Corps, who were training at Washington and Lee University.

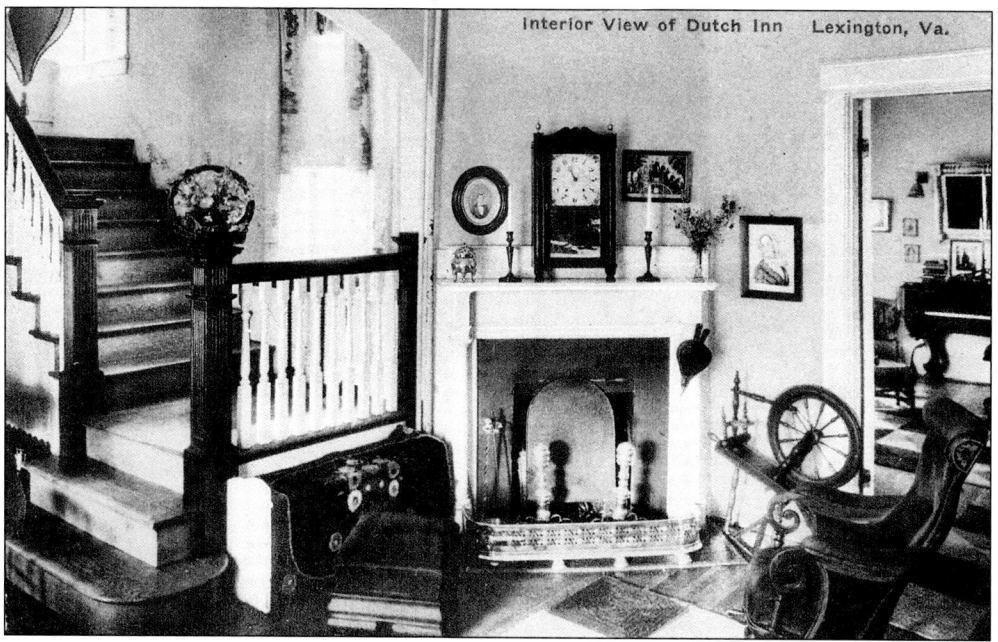

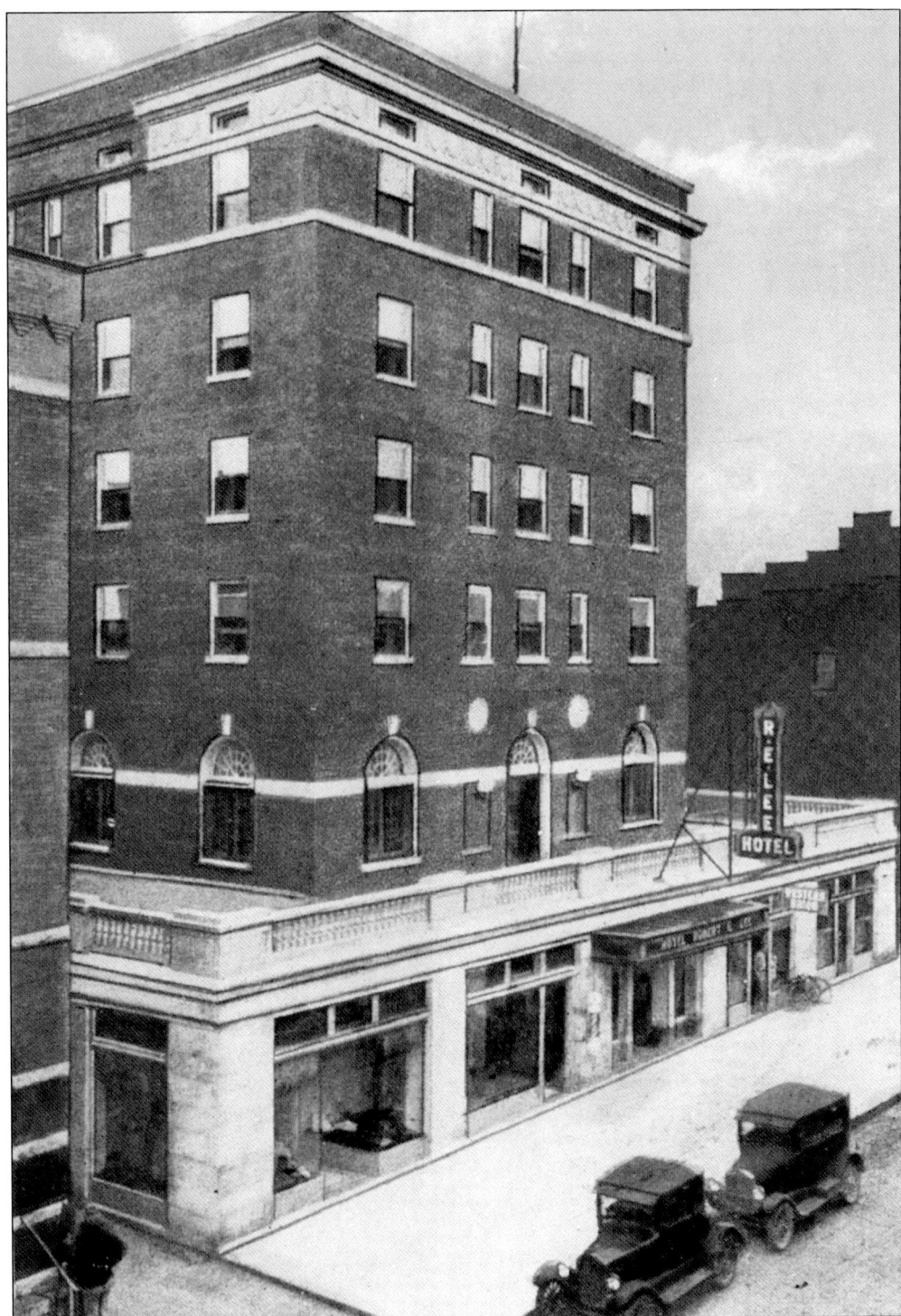

R.E. LEE HOTEL. Luxury had a new Lexington address with the opening of the Robert E. Lee Hotel in 1926. Lee's god-daughter pulled the cord that sent the American flag up its pole at the dedication. The hotel's construction cost a quarter of a million dollars.

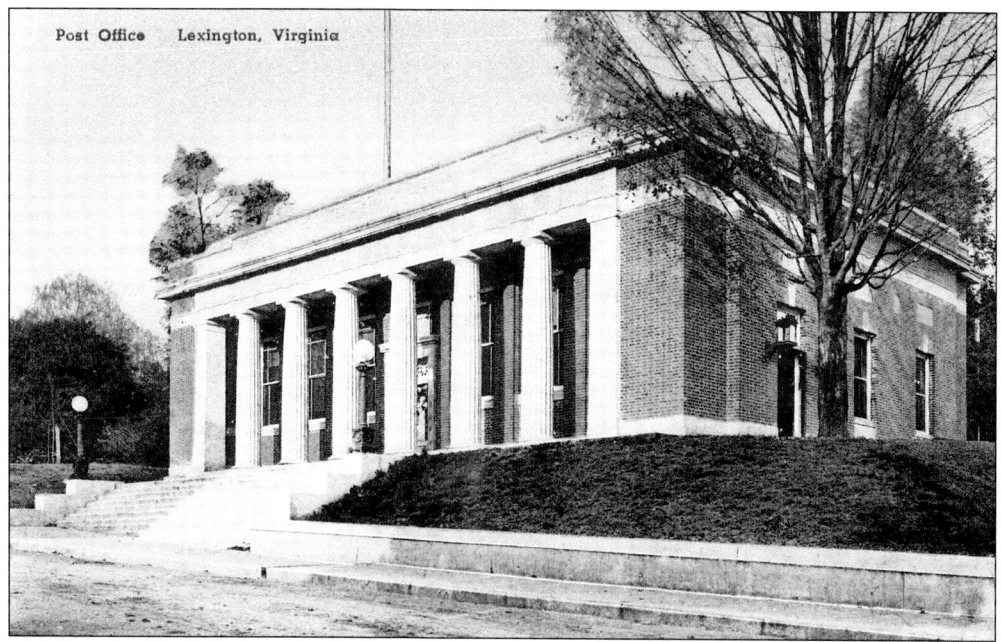

POST OFFICE. This building, constructed expressly to be a post office, was completed in 1913 at the corner of Lee Avenue and Nelson Street. With the exception of an addition to the rear of the building in 1935, it looks the same today. The postmaster has resisted modernity and kept the glass-windowed metal post office boxes in the main lobby. From time to time I still catch myself giving my mailing address as P.O. Box 127, Lexington.

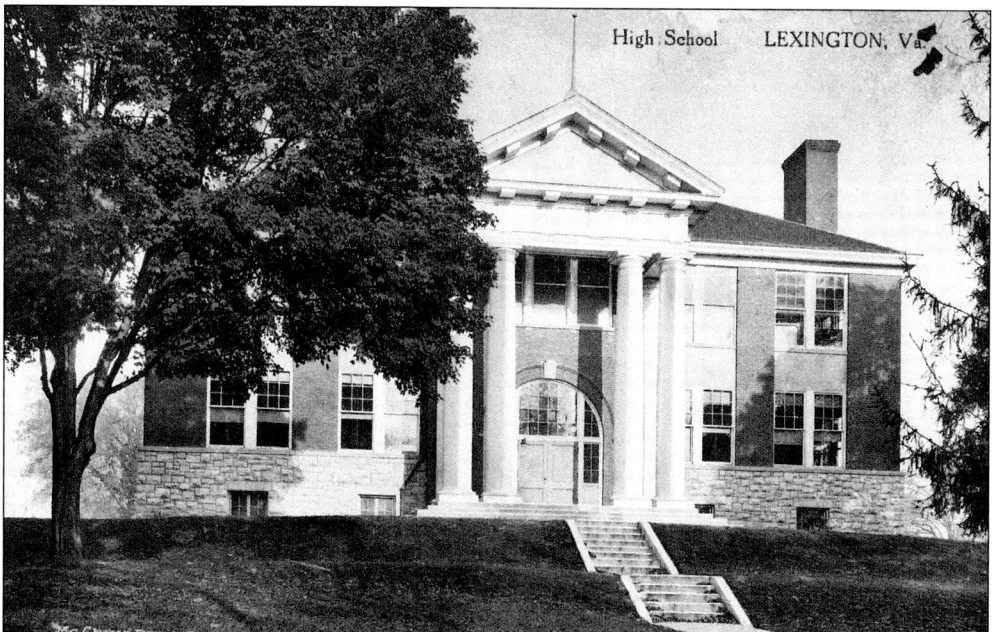

HIGH SCHOOL. Schooling in Lexington can be traced back to 1807, when the Ann Smith Academy, a school for girls, opened. Boys joined the ranks in 1877, and the school became Lexington High School in 1910. Now, it is the "Lodge," the Chi Psi fraternity house at Washington and Lee.

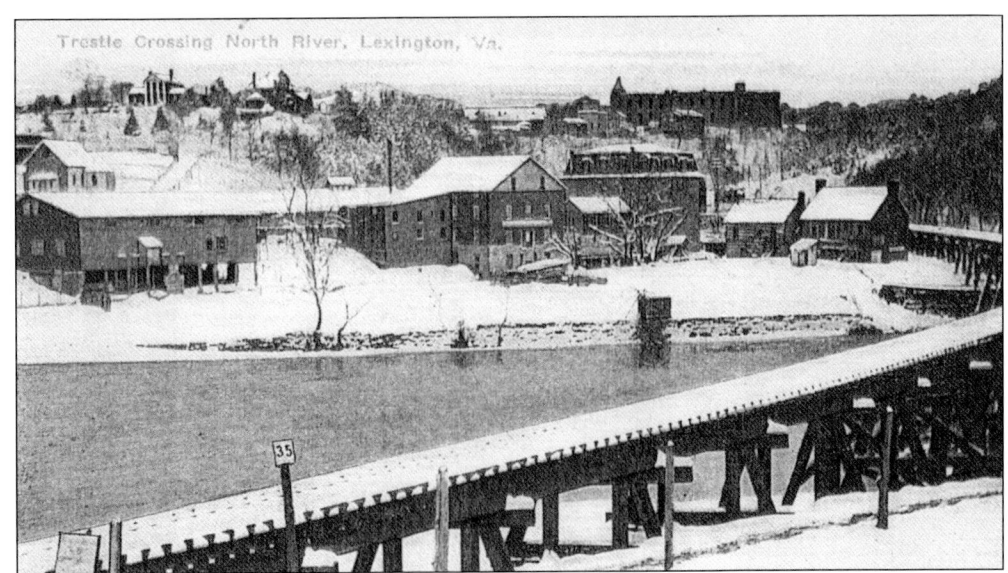

TRESTLE CROSSING NORTH RIVER. The Chesapeake and Ohio (C&O) train came to Lexington every day except Sunday. At East Lexington, the train used a "wye" to reverse itself for the final stretch. The steam engine then pushed the train up the the trestle, over the river, then behind VMI and W&L to reach the train station on Nelson Street. When it left Lexington, the engine would be at the front of the train for the trip to Balcony Falls, where travelers could connect with the C&O's James River line.

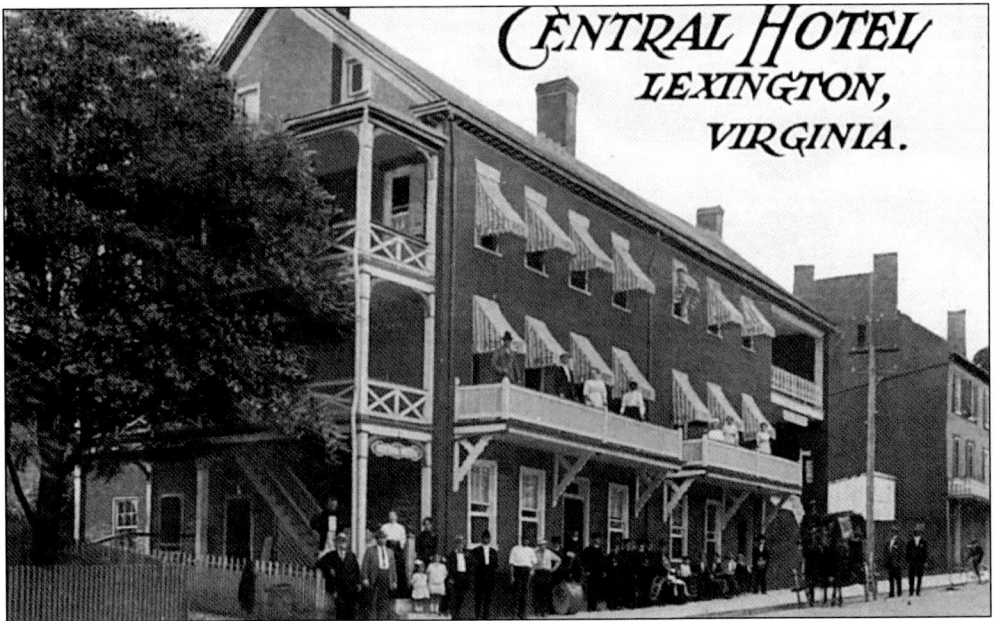

CENTRAL HOTEL. John McCampbell's home was built in 1809. After two additions and various business occupants, it was converted to the Central Hotel in 1907. Its most celebrated addition, a restaurant on the first floor called "The Liquid Lunch," was frequented by students, among others. In the 1980s the building regained its composure as the McCampbell Inn, a very comfortable place to stay. (Courtesy Special Collections, Leyburn Library, Washington and Lee University.)

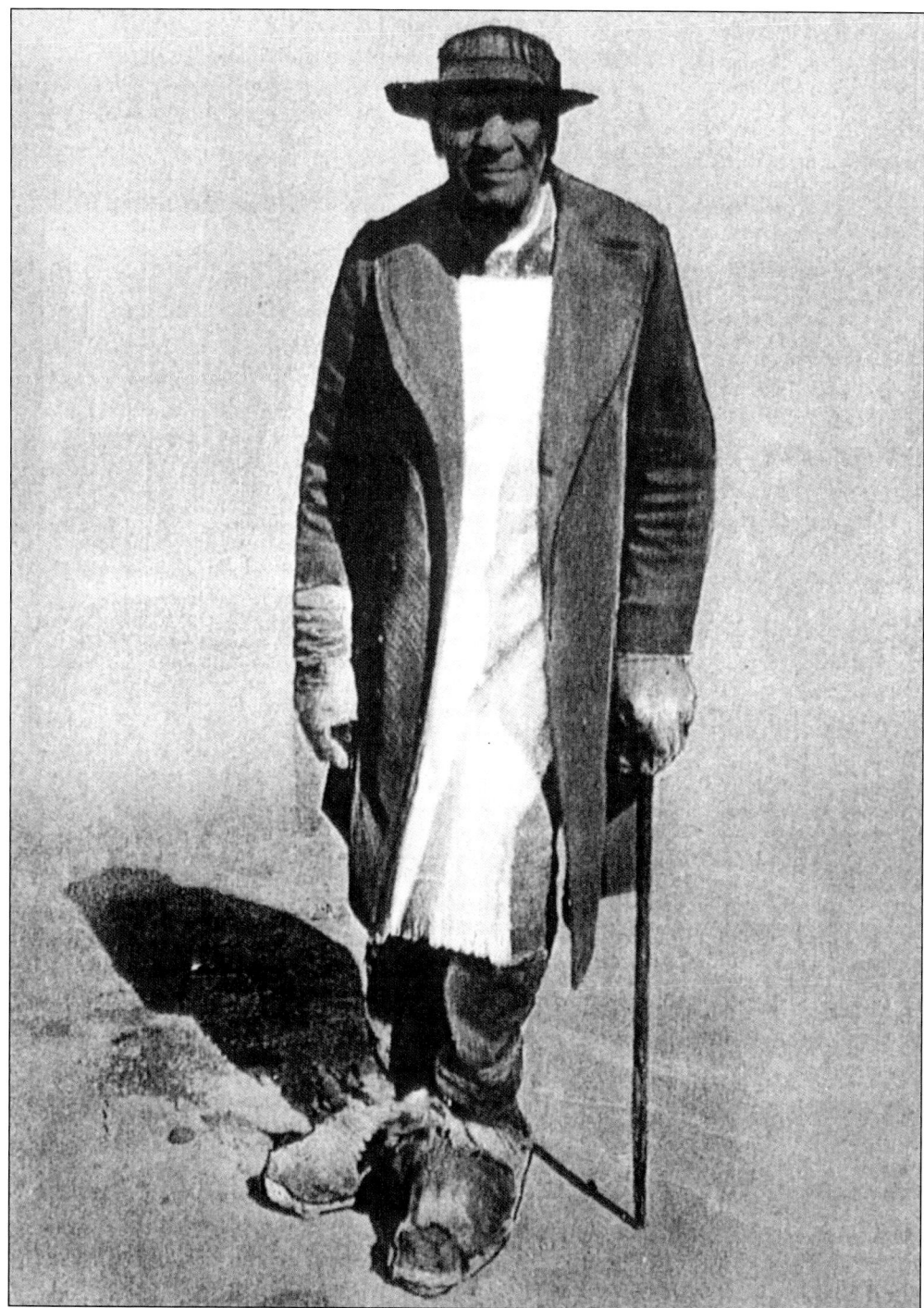

PHIL NUNN, "OLD DIXIE." This man, alternately called Dixie Nunn, sold postcards of himself outside McCrum's drugstore to bus passengers coming in for a bite to eat. He claimed when he was a boy he once held Traveller so Robert E. Lee could mount him. Phil Nunn was born a slave.

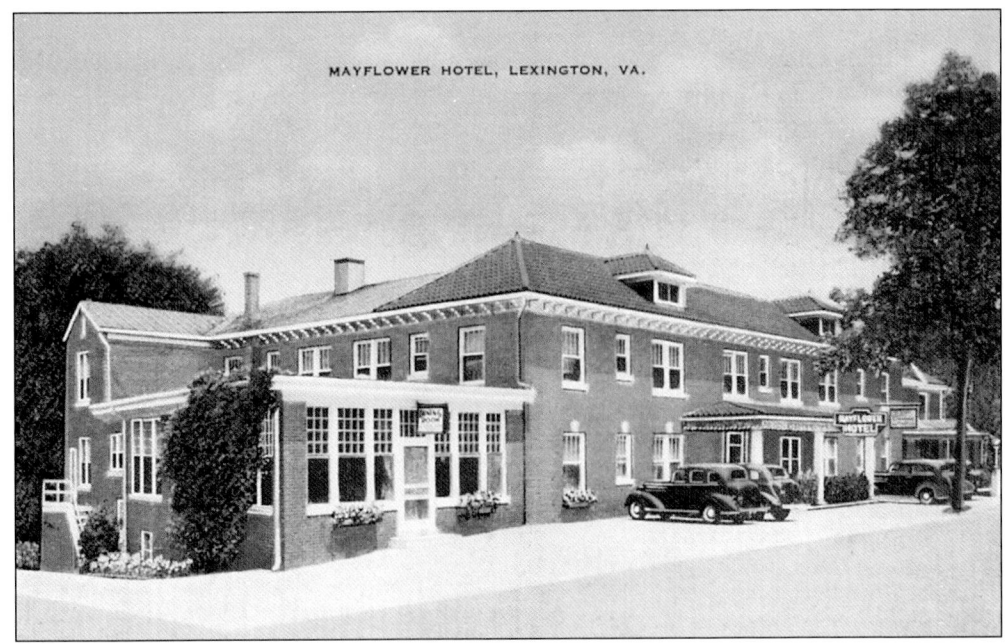

MAYFLOWER HOTEL. W.W. Coffey built the Mayflower Inn on South Main Street in 1929. The Pine Room, in the basement, was a popular social gathering place for many years. The building served as a hotel until 1983, when it was converted into a retirement home.

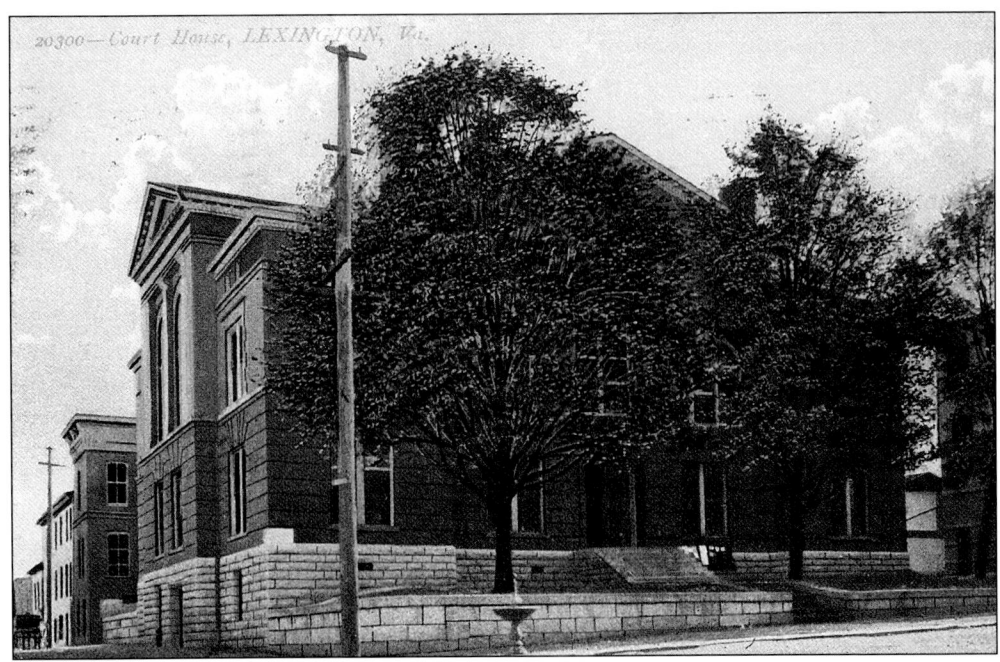

COURTHOUSE, POSTMARKED NOVEMBER 4, 1907. "Quite a building for such an old place!" This building, the Rockbridge County Courthouse, was dedicated on Confederate Memorial Day (June 2), ten years before this postcard was sent. It is the third courthouse built on this site, and the fourth one since the county was established in 1778. I often visited the courthouse on election night, when clerks fill in district tallies on chalk boards in the lobby.

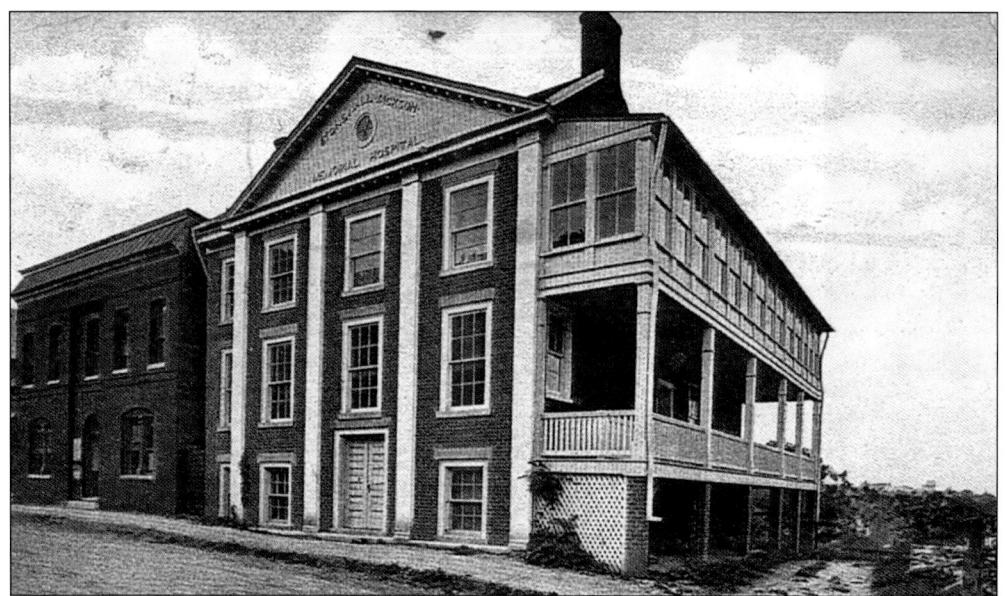

STONEWALL JACKSON MEMORIAL HOSPITAL, POSTMARKED JULY 23, 1910. In 1858, Jackson purchased his Lexington home, which had been built in 1801. The United Daughters of the Confederacy bought it from Jackson's widow in 1906. They converted it to Jackson Memorial Hospital, which opened the next year. In 1953, the new Stonewall Jackson hospital opened, and over the years the old building was used, among other things, as a boardinghouse. It was restored in 1979, and the Stonewall Jackson House is one of Lexington's prime tourist destinations. (Courtesy Special Collections, Leyburn Library, Washington and Lee University.)

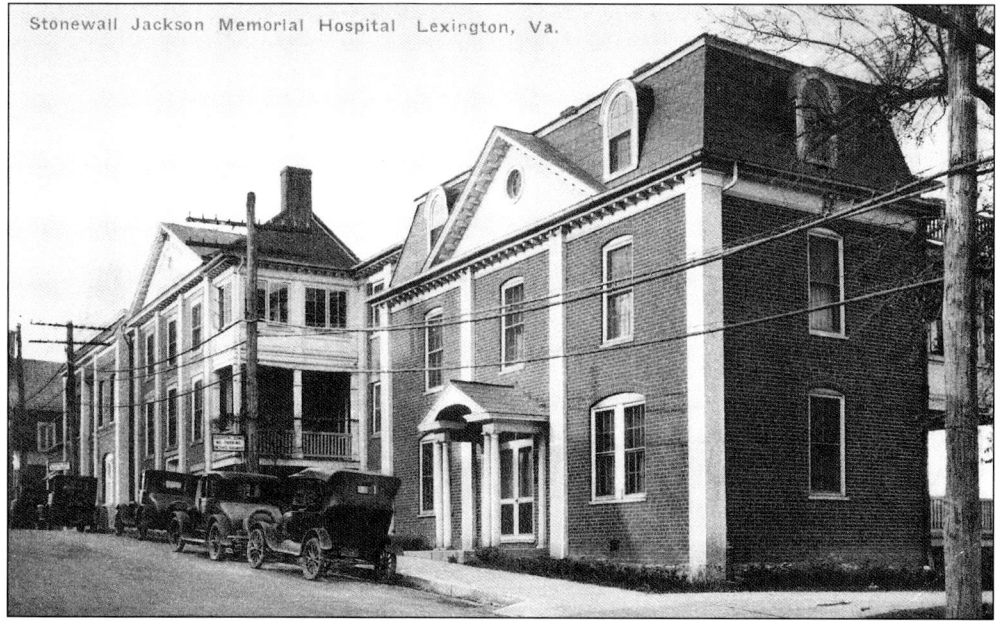

STONEWALL JACKSON MEMORIAL HOSPITAL. The building "down the hill" from Jackson's former home was the hospital nurses' dormitory. Called the Davidson-Tucker House, it now houses several offices, including that of the Historic Lexington Foundation. (Courtesy Special Collections, Leyburn Library, Washington and Lee University.)

STONEWALL JACKSON MONUMENT. The postcard to the left is postmarked July 26, 1911. This statue by Edward Valentine was dedicated in Lexington's cemetery on July 21, 1891. Shortly after Jackson's death in 1863, he was buried in his family crypt at the cemetery. In 1875, the Jackson Memorial Association was formed; members raised the $9,000 cost of the statue. Jackson was reburied beneath it. (Top postcard courtesy Special Collections, Leyburn Library, Washington and Lee University.)

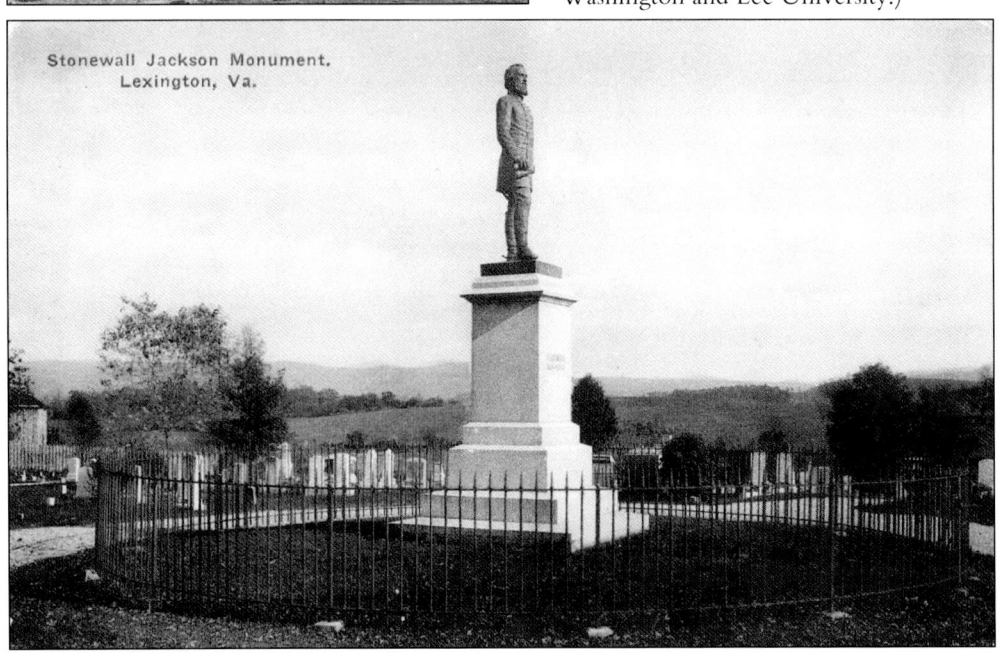

Three

THE WEST POINT OF THE SOUTH

I've never been envious of the life of a Virginia Military Institute cadet. I do have great respect for their discipline and dedication. Their studies are completed in much the same Spartan environment as their counterparts one hundred years ago. Their pride in their school is well placed. They display it every day.

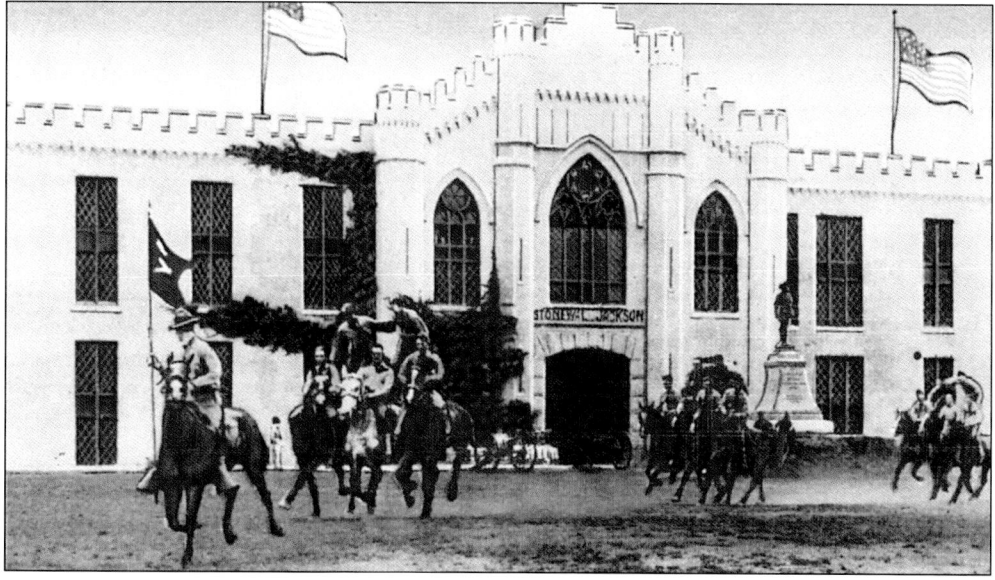

EXHIBITION RIDING BY CAVALRY TROOPS. "The Virginia Military Institute, founded in 1839, has won and richly deserves the title of 'The West Point of the South.' The valiant and courageous part played by the students of this institution in the War Between the States will go down in history as one of the highlights of this War. General Thomas J. (Stonewall) Jackson was a professor here at the outbreak of the Civil War and is buried at Lexington, Va. A monument in his honor stands on the campus in front of the main barracks of VMI."

STONEWALL JACKSON MEMORIAL HALL. Construction began on this building in October 1915. The first Jackson Hall had been paid for with funds collected to erect a memorial to Jackson at VMI. It was demolished to make way for other construction.

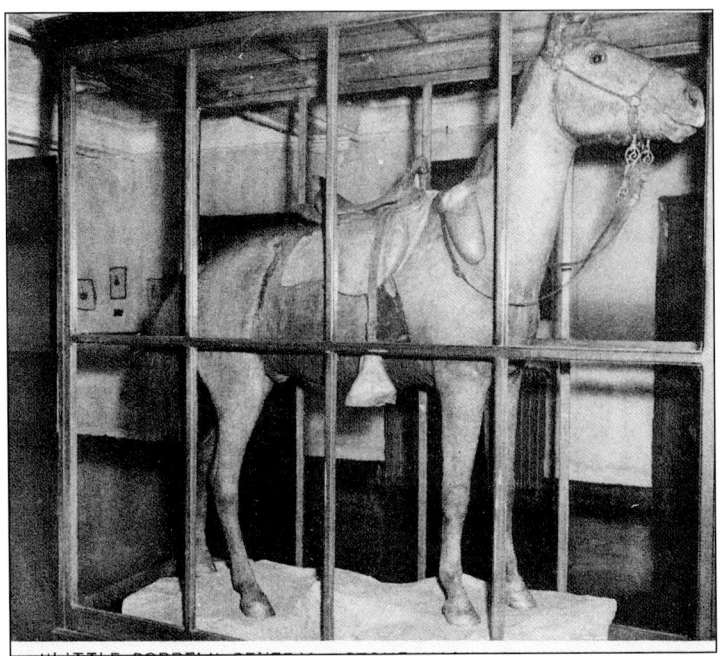

LITTLE SORREL, GENERAL "STONEWALL" JACKSON'S WAR HORSE, VIRGINIA MILITARY INSTITUTE. Legend has it that people pulled so many hairs out of Little Sorrel's tail as souvenirs, that he "hardly had enough tail to shoo away the flies." He died in 1886 at age 35. The stuffed hide of Little Sorrel stands in the VMI museum; his bones were buried in 1997.

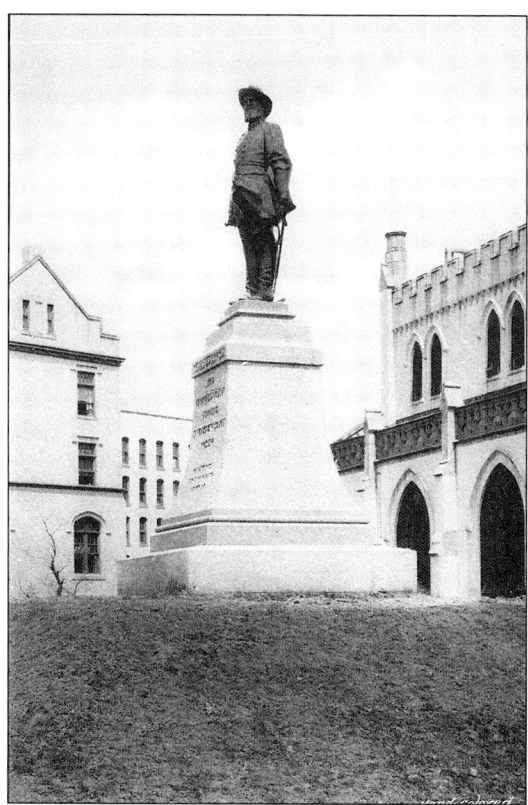

EZEKIEL'S STATUE OF JACKSON, VMI. This statue, actually a replica, was unveiled in 1912. The inscription on its base reads, "Stonewall Jackson/The Virginia Military Institute will be heard from today/General Jackson at Chancellorsville/May 2, 1863." The original, commissioned by the West Virginia United Daughters of the Confederacy, was placed in the state capitol. (Courtesy Special Collections, Leyburn Library, Washington and Lee University.)

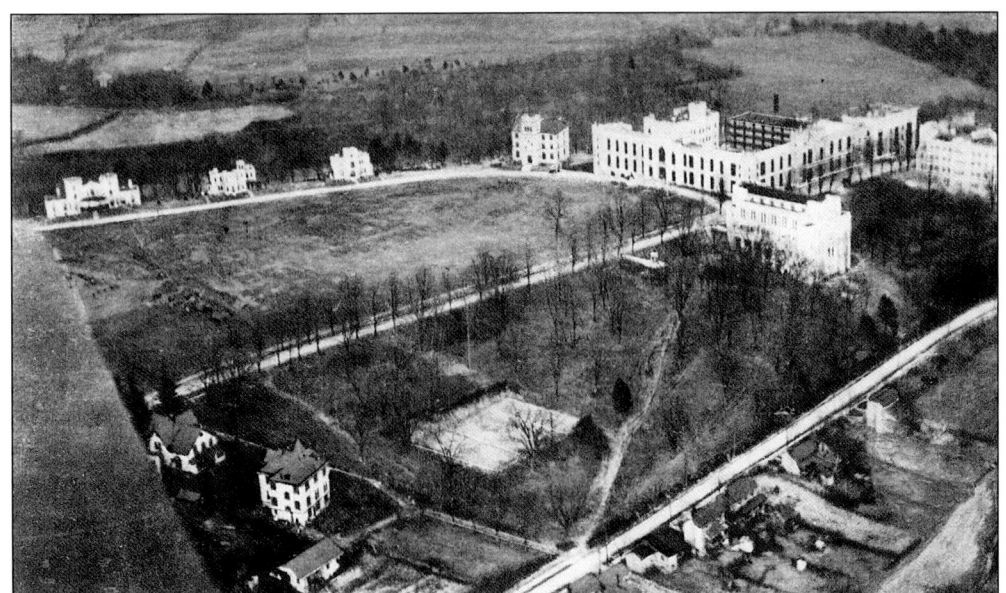

AERIAL OF VIRGINIA MILITARY INSTITUTE, POSTMARKED JANUARY 13, 1923. "We enjoyed the sights and history of Lexington yesterday. Father graduated here in 1855 and his father at Washington College long before that. We do nothing much but eat and talk and sis is getting fat. Love for your mother—Lyde C. Wilson."

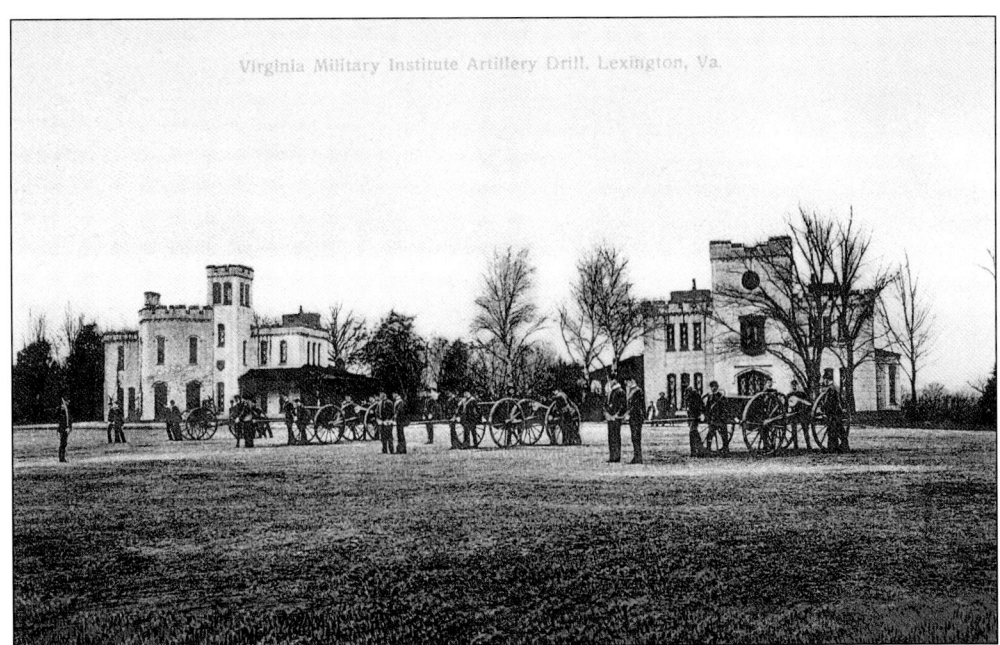

ARTILLERY DRILL. Administrators of VMI consider their approach to education a "three-legged stool" of academics, military training, and athletics. Roughly 1,200 cadets are enrolled at the school with the pursuit of becoming "citizen-soldiers." VMI's most famous graduate is General of the Army George C. Marshall, Class of 1901, the only soldier to win the Nobel Peace Prize.

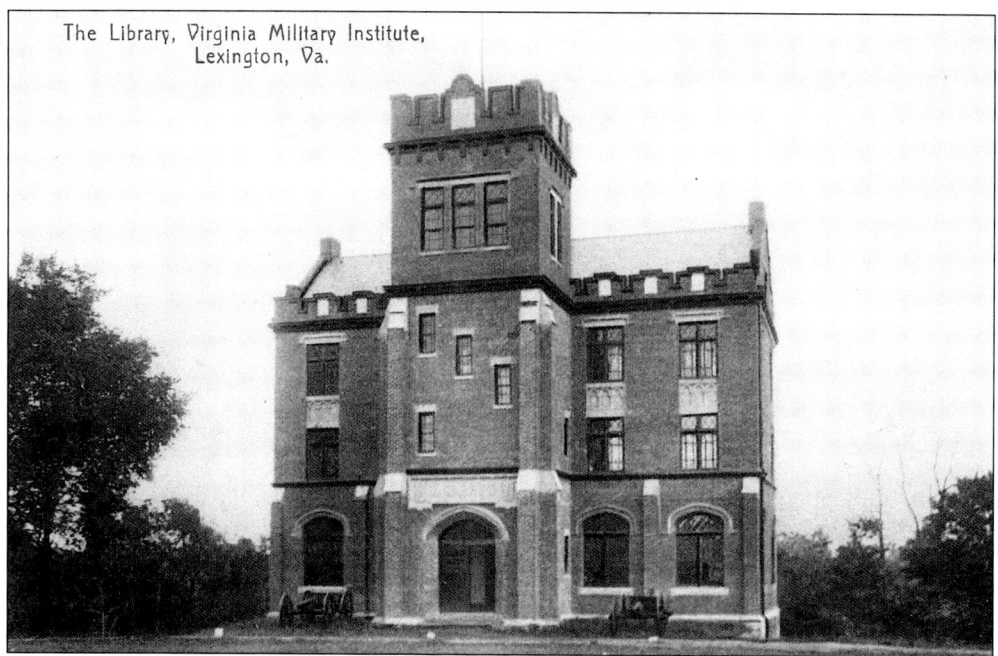

THE LIBRARY. This building was built to house VMI's books in 1907. It served as the library until 1939, when the new Preston Library opened. The old library was used for a variety of purposes until 1949, when it was torn down to make way for the new barracks.

THE MESS HALL, POSTMARKED AUGUST 6, 1911. In the 1920s, when my grandfather, Montie Weaver, was a student at Emory and Henry College, he often came to Lexington to play baseball against Washington and Lee at VMI's field. Sometimes he took his meals at the mess hall. He told me how the "rats," the freshmen at VMI, were required to sit stiffly at dinner, and if any upperclassman cadet wanted something to drink, he would throw his glass at the rat, who had to grab it before it hit him. (Courtesy Special Collections, Leyburn Library, Washington and Lee University.)

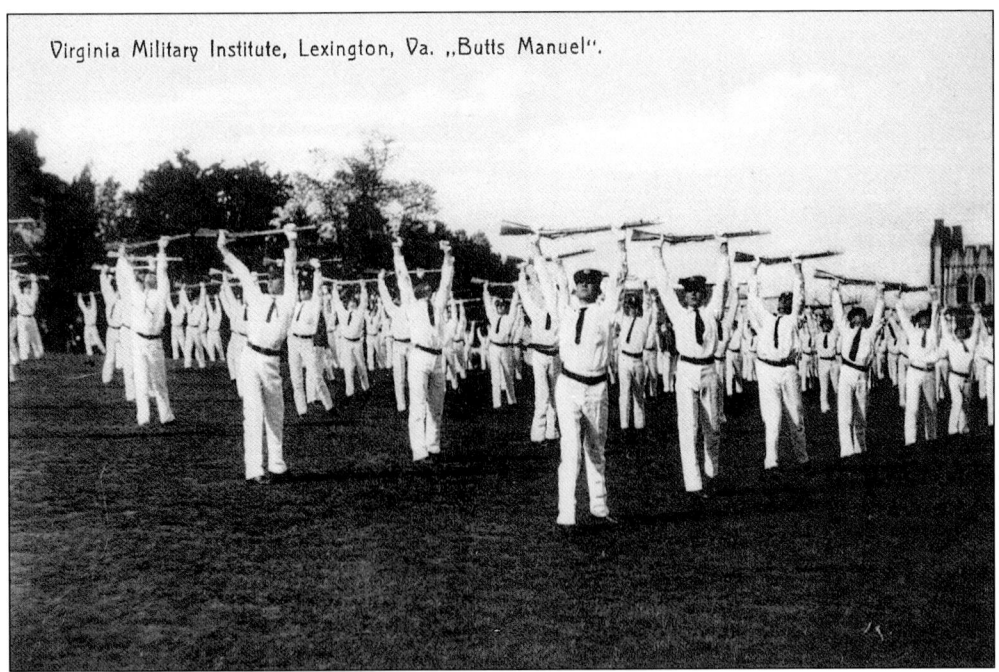

BUTTS MANUEL. In the period 1905–1920, the "Butts Manuel" exercise was common. Cadets would do calisthenics while holding a rifle. The "Butts Manuel" was taken from a U.S. Army book of exercises published by Edmund Luther Butts in 1902.

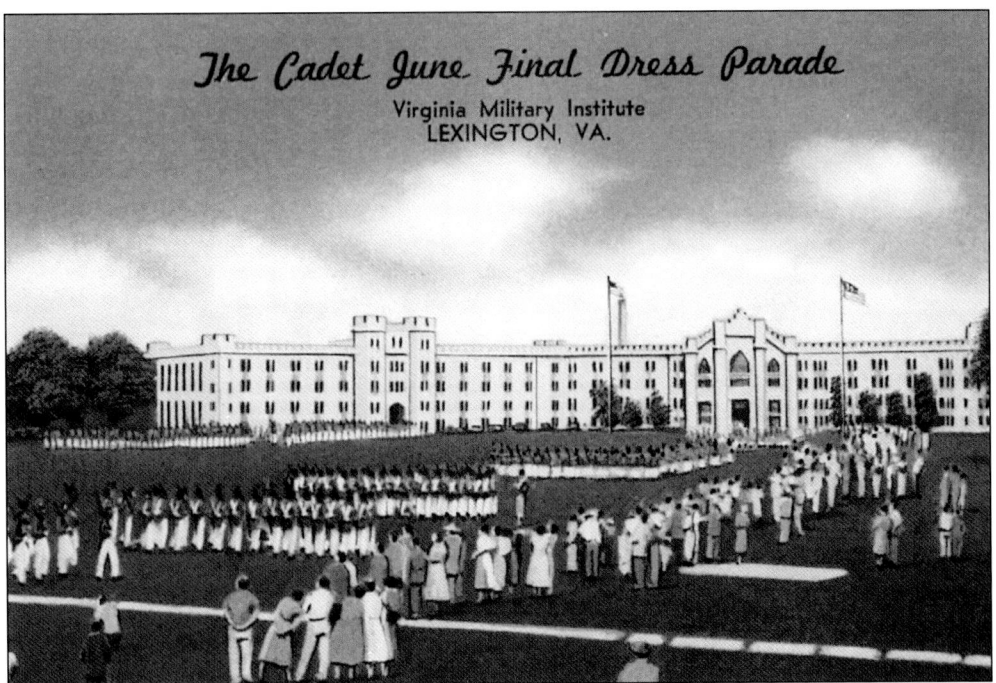

THE CADET JUNE FINAL DRESS PARADE. VMI cadets hold one final parade before their professors and their families as part of graduation traditions. During the school year, the cadets hold parades on the grounds for review by guests and tourists, as well.

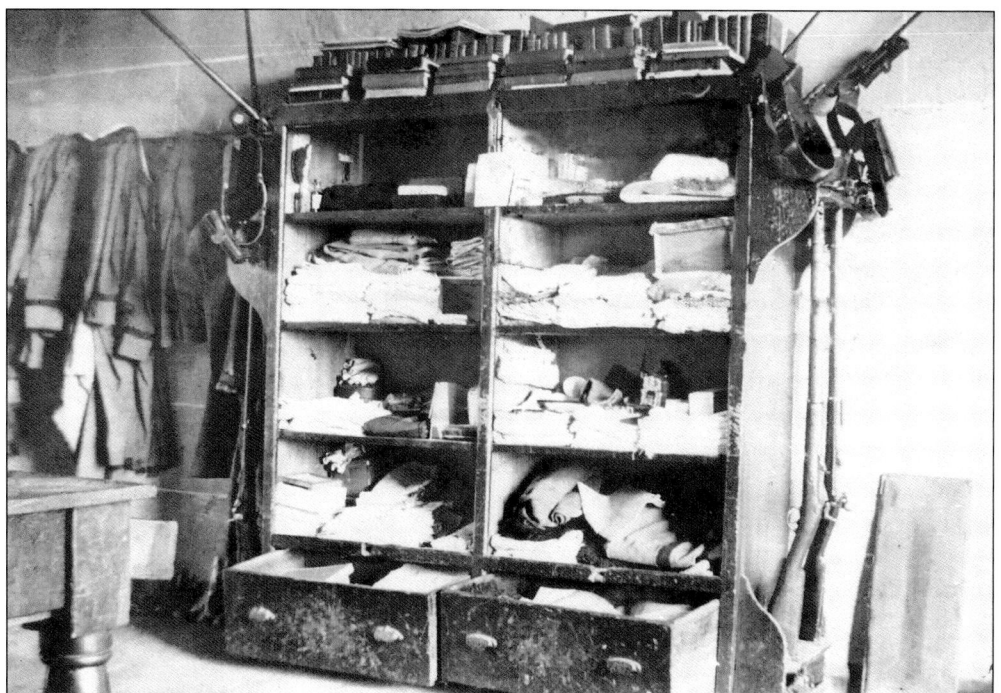

REAL LIFE AT VMI. Both of these postcards are postmarked December 24, 1907, and addressed to the same person. Before 1925, VMI cadets were not granted a furlough to leave the post to see their families at Christmas. It was traditional for an order to come December 24 announcing there would be no reveille or classes the next day. The VMI campus can be bleak during much of winter; that must have been obvious more so during the holidays. "How do you like our furniture?" was written on the back of the above card, and "This is the way we sun our bed clothes" on the lower.

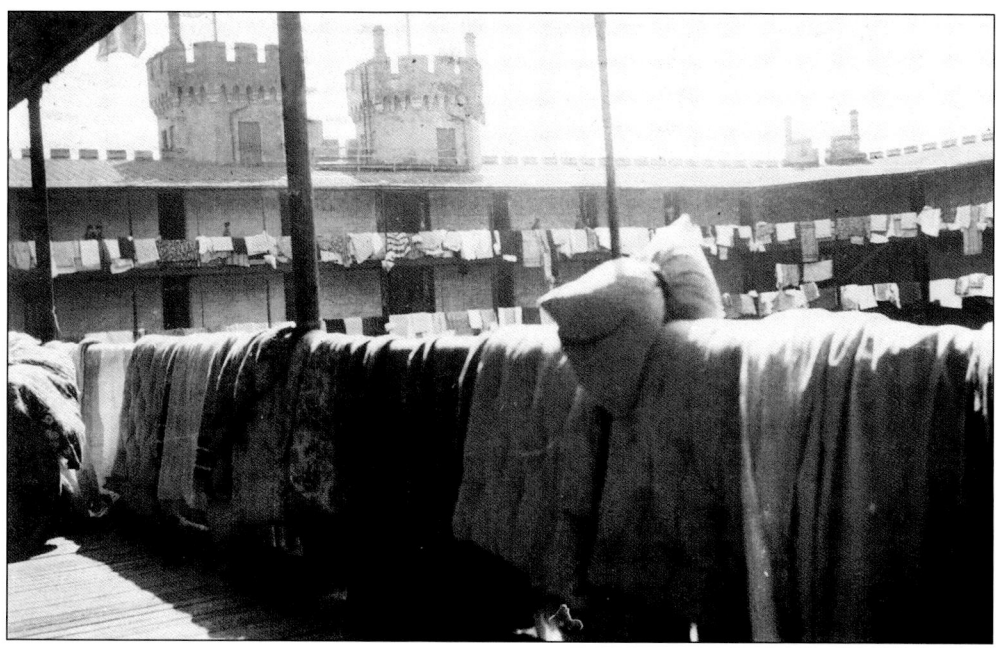

HOUDON'S STATUE OF WASHINGTON. This statue is a bronze cast of Jean Antoine Houdon's marble (see page 105). It was the first full bronze in the United States, and was completed in 1856. The statue was taken to Wheeling, West Virginia, by Union troops after Hunter's Raid in 1864. That state's governor returned it in 1866.

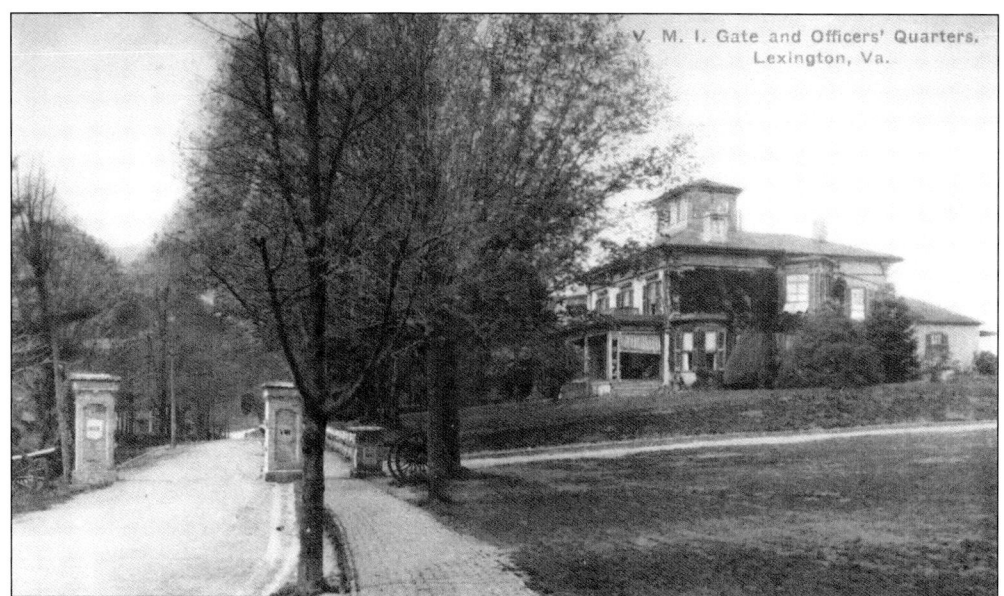

VMI GATE AND OFFICERS' QUARTERS. No one knows when the gate was put up, but it probably was done in the mid-19th century. It stands in the background of countless photographs of sons and grandsons who have followed their relatives' paths to be educated and shaped at VMI.

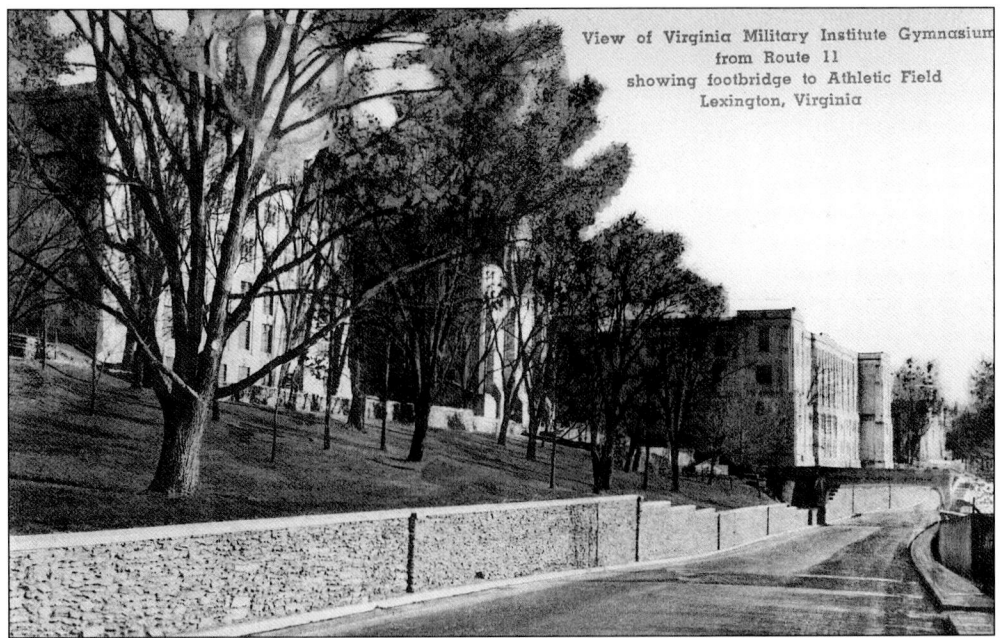

VIEW OF VIRGINIA MILITARY INSTITUTE GYMNASIUM FROM ROUTE 11 SHOWING FOOTBRIDGE TO ATHLETIC FIELD. Travelers headed north on 11 pass under this bridge, which was constructed in the 1930s. When there's a big game at the field, cars line the sides of the road before and after the bridge. Sometimes W&L students wander over with a cocktail in hand to watch the competition, especially if it's the Lee-Jackson game, when the two schools compete in lacrosse.

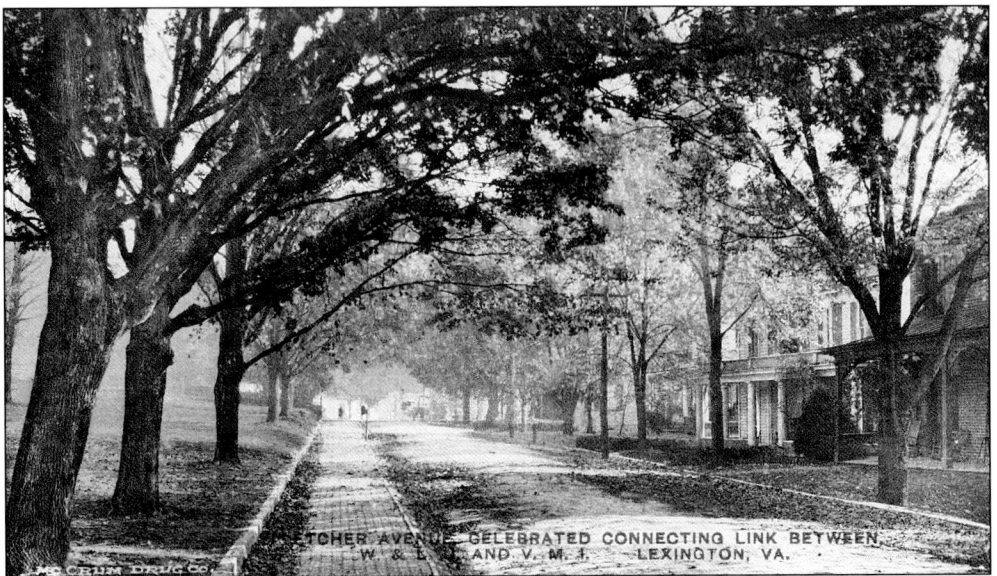

LETCHER AVENUE. Old houses and sunken brick sidewalks line the street that links VMI to Washington and Lee. There is also a marker on Letcher called the Lexington Triad, commemorating the three college fraternities that were started in Lexington: Sigma Nu and Alpha Tau Omega, both of which began at VMI; and Kappa Alpha Order, which was founded at Washington and Lee.

Four

GENERAL LEE'S COLLEGE

Washington and Lee University celebrates its 250th anniversary in 1999. As an institution, it is far removed from its first incarnation, Augusta Academy, a small preparatory school for boys. The principles that guide the school have remained the same since Robert E. Lee came to Lexington to lead a later incarnation called Washington College. His vision of honor is practiced by students of the institution now partially named for him.

RUINS OF OLD LIBERTY HALL ACADEMY. What remains of Liberty Hall, the successor to Augusta Academy, sits on a hill set away from the athletic fields and most of the modern W&L campus. Here, students gather for tail-gate parties before football and lacrosse games. Nowadays, at Liberty Hall, there is a "strict" uniform of white or blue shirts and khakis for men, and flowered dresses for women. This includes parents, who may join their sons and daughters here at Parents' Weekend. (Courtesy Special Collections, Leyburn Library, Washington and Lee University.)

WHEN THE LEAVES BEGIN TO FALL. The Colonnade is the centerpiece of the Washington and Lee campus, and the subject of many postcards taken from slightly different angles to capture it in just the best light and perspective. The Colonnade is composed of Newcomb Hall, Tucker Hall, and the three buildings of the "Washington College Group": Washington Hall, Robinson Hall, and Payne Hall. It was named a National Historic Landmark in 1972.

PRESIDENT'S HOUSE. Subsequent presidents of the college after Robert E. Lee have lived in his home on campus. Several times a year, students and their parents are invited inside for hors d'oeuvres and drinks, and a kind word from the university president and his wife.

SCIENCE HALL, POSTMARKED AUGUST 8, 1908. The columns of this building, Reid Hall, face away from the main campus; it looks like an acropolis to those on the athletic fields. Reid became the home of the school of journalism in 1964, and now sports TV and radio antennae. I interviewed an alumnus U.S. senator in the hall's TV studio—his former biology laboratory.

LEE'S DORMITORY. This postcard's printer likely thought the name of the building, given its location, was "Lee's," but it was named for Susan P. Lees, who gave $30,000 for its construction. The Lees dormitory was later combined with another to create Graham-Lees, one of three dormitories where freshmen live. (Courtesy Special Collections, Leyburn Library, Washington and Lee University.)

WINTER ON THE COLONNADE. I lived in Florida all my life, until I came to Lexington. I saw snow for the first time my freshman year, at about three in the morning one winter night. Something about snow makes any loud sound louder, in particular the screams of other students playing in their first snow. Soon there was a knock at my door, and when I opened it, my very first snowball came through, courtesy of a fraternity brother.

CAMPUS. Students and their parents sit on folding chairs for annual Parents' Weekend fried chicken lunches on this lawn. Graduation is held here too; then, there are bottles of champagne tucked under students' folding chairs courtesy of their parents.

WORLD WAR MEMORIAL GATE, POSTMARKED NOVEMBER 3, 1928. The university inscribed the names of the alumni war dead here, beginning with casualties from World War I. Visitors who drive to Lee Chapel pass through the gate when they visit the tomb of the Great Chieftain.

BIRD'S-EYE VIEW OF WASHINGTON AND LEE UNIVERSITY. The school throws the best parties on the front lawn for events like Homecoming and Alumni Weekend. It brings out bands, a buffet, and a bar, and it couldn't be more pleasant to spend the afternoon there.

THE FRONT LAWN, POSTMARKED APRIL 12, 1949. This was the first day of issue for a postage stamp celebrating Washington and Lee University's 200th anniversary. Those stamps are still prized by students who buy them at a premium to send graduation announcements, and by alumni who do the same to mail wedding invitations. (Courtesy Special Collections, Leyburn Library, Washington and Lee University.)

LEE-JACKSON HOUSE. The dean of students lives in this house, one of four similar houses flanking the Colonnade. It is the only one still used as a residence; the other three are the university guesthouse, an art museum, and the office of university admissions.

MEMORIAL BRIDGE AND WILSON ATHLETIC FIELD. This bridge, the "footbridge" in campus parlance, crosses the breech formed by Woods Creek on the back side of the undergraduate campus. More than one student has accepted the dare to run its length on the handrails.

CLASS MEMORIAL BRIDGE TO ATHLETIC FIELD, POSTMARKED SEPTEMBER 20, 1930. The perspective of the postcard and the significant drop-off make it impossible for the building shown to have existed there. Perhaps it is meant to represent an old gymnasium that once occupied the land near the athletic field.

Top: Professor's Residence. This is now home to the Reeves Center, where many works in the university's art collection are kept. The obelisk next to it honors John Robinson, a Washington College trustee who bequeathed his entire fortune to the school; it was erected in 1855 and restored in 1939. *Bottom: The Wisteria in Bloom, Postmarked August 9, 1937.* It shows how the residence matches the style of the neighboring buildings of the Colonnade.

THE COLLEGE. Most of the school is located on "The Hill," as students call it. I'd say, over the course of the four years students attend school here, they will climb it at least a thousand times. I think I made my fastest ascent the night the graduation list was posted outside the registrar's office. The totaling of the sufficient number of credits, even coupled with confidence in the last round of exams, is not as reassuring as seeing your name on that definitive list.

TUCKER MEMORIAL HALL, POSTMARKED SEPTEMBER 9, 1910. Many people did not regard this building, the Washington and Lee law school, as a complement to the Colonnade. Arson was suspected when it burned in 1934. The rebuilt Tucker Hall was fashioned to blend in better; it housed the law school until a new building was built for that purpose in the 1970s. Tucker is now home to the psychology and foreign language departments. (Courtesy Special Collections, Leyburn Library, Washington and Lee University.)

VIEW FROM DOREMUS. These buildings, from left to right, are actually Reid Hall, Carnegie Library, Dining Hall, and Dormitory. They are home to numerous contented students who may follow a routine of working on a newspaper article in one place, then filing a paper in a professor's mailbox 15 minutes before a midnight deadline, getting a snack, and then heading to bed to prepare for the demands of the next day.

THE DOGWOOD BLOOM, POSTMARKED APRIL 10, 1917. "Dear Maria—I hope dear little Mary is well and sleeps well. I miss her very much. Everyone likes Anna. She is so happy here . . . Everyone in town is going to the wedding tonight. Give a big hug to dear Mary. Remember me to everyone."

NEWCOMB HALL AND MAIN BUILDING. If there were ever a building that could make anyone want to be a history student, it is Newcomb Hall. When the winter sun shines just so through the wavy panes of the windows, the worn tables and creaky chairs in my favorite classroom on the second floor invite you to delve deeper into the adventures of the Romans or the British, or whomever you're studying.

CARNEGIE LIBRARY. Andrew Carnegie paid $50,000 of the $55,000 price of this library. In 1940, a $100,000 gift went to rebuilding and enlarging the building, which was then renamed the McCormick Library. In 1979, the books moved to the new University Library, which was later named the Leyburn Library. McCormick became the school of commerce, later renamed the Williams School.

WASHINGTON AND LEE UNIVERSITY, LEXINGTON, VA.

Back to Washington and Lee

Ship me back to old Virginia,
 Where the summer skies are blue,
Where the gods walk on the hill tops,
 In the sunset's rosy hue.

For I've heard their voices calling,
 And it's there that I would be,
In the shadow of the mountains,
 Back at Washington and Lee.

By the Banks of old North River,
 Winding lazy round the hill.
To the dear old College Campus,
 My thoughts are turning still.

For the college bells are calling,
 And I know they say to me,
Come you back, you old Alumnus,
 Back to Washington and Lee.

Five

THE LITTLE PITTSBURGH OF THE SOUTH

On Interstate 81 South, there is a regular-sized highway sign that indicates it is 20 miles to Lexington. And a smaller sign attached at the bottom adds "Buena Vista." The town is often in the shadow of its better-known neighbor, though its people are often called on to make decisions with other county residents about what is best for Rockbridge. As with many small towns, the characters reign, and their decisions often entertain newspaper readers.

GREETINGS FROM BUENA VISTA, VA., POSTMARKED JANUARY 25, 1936. "Dear Elmer: I read your Xmas card so proud to know you thought of me please write and come to see me I get so lonesome and can't see to write myself. Lots love grand ma."

BIRD'S-EYE VIEW, LOOKING NORTH, BUENA VISTA, VA, POSTMARKED JUNE 9, 1942. Buena Vista is a quieter town than Lexington; it has its share of small shops and pretty houses. When the governor signed the charter for the city in 1892, the area was "booming" with potential, with a new nickname at the ready—"Little Pittsburgh of the South." The area's iron ore deposits were quickly exhausted, though.

VIEW OF TWENTY-FIRST STREET. Many buildings from the "boom-times" remain, including the original city office building, as well as the former courthouse, which was recently restored. The new streetlights even replicate the old kind. (Courtesy Special Collections, Leyburn Library, Washington and Lee University.)

SCENE ON NORTH RIVER, SHOWING BLUE RIDGE MOUNTAINS, BUENA VISTA, VA. The Blue Ridge Parkway is a short distance away. In the material given to arriving W&L freshmen, "driving on the parkway" at sunset is on the list of "Must-Do." And on a list of local lingo, this town is appropriately referred to as "B.V." And the North River is now called the Maury River.

Top: **U.S. Post Office, Buena Vista, Virginia.** *Bottom:* **General View of Southern Seminary and Blue Ridge Mountains, Buena Vista.** Buena Vista got its name from the nearby Buena Vista iron furnace. That area of the country had been previously called Green Forest and Hart's Bottom.

Six

"One of the Seven Natural Wonders of the World"

Rockbridge County owes its name to Natural Bridge, which is about 14 miles south of Lexington and a few miles to the west of the Blue Ridge Mountains. The Monacan Indians revere it as "the Bridge of God." They believe the Great Spirit created the bridge to allow them to cross a huge canyon and escape attacking tribes. The Monacans were then able to hold the bridge and defeat their enemies from it.

HISTORICAL MARKERS. "George Washington surveyed Natural Bridge in 1750 for King George III of England, under the supervision of Lord Fairfax. Thomas Jefferson acquired the Natural Bridge and 157 acres surrounding the Bridge from King George III for 20 shillings on July 5th, 1774."

NATURAL BRIDGE PANORAMA. The bridge typically draws its largest crowd on Easter Sunday, when a service is held at sunrise along the Cedar Creek Trail. Every day, at sunset, there is the *Drama of Creation*, a sound and light show with the bridge as a centerpiece.

NATURAL BRIDGE HOTEL. Thomas Jefferson built the first hotel in the Natural Bridge area, a two-room log cabin in 1803. Subsequent hotels were anywhere from 2 miles away to right next door to the bridge. The grandest hotel at Natural Bridge, pictured here, was often advertised as a casino after the center section was completed in 1906, but it mostly catered to visitors curious to see the famous bridge. This hotel was made of wood and burned in 1963. It was replaced with a brick structure on the same site.

SWIMMING POOL, NATURAL BRIDGE, POSTMARKED JUNE 13, 1910. "This is a dandy pool, but rather cool weather. I think of taking a swim . . ."

Natural Bridge Motor Lodge, Natural Bridge, Va.

NATURAL BRIDGE MOTOR LODGE. There are a great number of things about Natural Bridge that attracts connoisseurs of "Roadside America." Besides the bridge itself and the stately hotel, there are kitschy shops and a wax museum, and a motor lodge to house the patrons.

Salt Petre Cave, Natural Bridge, Virginia

SALT PETRE CAVE, NATURAL BRIDGE, VIRGINIA. *Top:* "Salt Petre was mined from this cave to make ammunition for the wars of 1812 and 1862. Water was piped from Lost River 400 yards upstream for processing." Thomas Jefferson directed early production at the salt petre cave, which is located just above the bridge. Nearby, workers dropped molten lead off the bridge into the water below to create bullets for fighting the British. *Bottom:* "The Lost River at Natural Bridge of Virginia is a small body of water flowing under a mountain side. No one knows where this stream comes from or goes to. A genuine curiosity of nature."

The Lost River at Natural Bridge, Virginia

Natural Bridge Hotel

Natural Bridge, Va.

"BRIDGE OF YEARS"

Gigantic arch of everlasting stone,
Cut by the hand of God while ancient time
Looked down in wonder on a new-made world.
How many centuries through thy portals vast
Since that far hour have joined eternity
What was the might of Caesar, hedged with
steel
And robed in royal purple, unto thine?
He came, he saw, he conquered and he passed.
Beneath a wreck of years imperial Rome
Lies buried. And behold, where sleeps the Nile,
How Egypt mourns her crumbling pyramids.
In antique days, while shepherds watched at
night,
In Syrian skies was lit the Star of Life
Yet even then thy towering bulk was old
And stained with passage of the centuries.
Man, the proud pygmy, master of an hour,
Vain shadow on the shifting sands of time,
In supercilious impotence surveys
Thy majesty eternal. As he stares
The phantom of dead ages rises up
And strikes his soul to silence. Structure vast,
Lone, immemorial, massive monument,
Lifted in triumph to the march of years,
At thy fixed base, as at the feet of God,
We kneel in reverence and humility.

<div align="right">Carter W. Wormeley</div>

Seven
ROCKBRIDGE BACK ROADS

Someone already beat me to the idea of a book mapping out the back roads. I'd say the Goshen area is the prettiest to drive, but there are plenty of people who would disagree. This is a fantastic place to see the fall leaves and take some pictures.

GOSHEN PASS, VIRGINIA, POSTMARKED MAY 19, 1908. "On the one side frowning rocks, on the other tree-clad mountains, precipitous and high, while North River goes foaming through below to the music of its gurgling cascade or roaring fall. No picture can do this magnificent pass justice. Embowered in rhododendron and ferns the road is cut into the mountains side and so impressed with the beauty of the scenery was the world-travelled Commodore Maury that by request his remains, for a while, were stopped in the center of the gorge before passing on to the final resting place."

THE MAURY MEMORIAL IN GOSHEN PASS, VIRGINIA, POSTMARKED AUGUST 14, 1928.
"Virginia's tribute, located in Goshen Pass east of Staunton, in honor of a native son who won fame as 'the Pathfinder of the Seas.'"

GOSHEN PASS TO SOUTHWESTERN VIRGINIA. Route 39 is likely the most traveled road to Goshen. It is best driven in a convertible, or at least in a car with the windows down, so as to better appreciate springtime. A proper trip is not complete without food and drink, the latter easily cooled in a nook under the rapids. Above water, there are plenty of rocks for a picnic. Afterwards, it is best to take off your watch and shoes, find a seat on a sunken rock and relax.

GOSHEN PASS. Stagecoaches used to travel through Goshen Pass, which at different times has also been called the Valley of the Great Calf Pasture, Dunlap's Gap, and Strickler's Pass. Nowadays, innertubes are a more common means of transportation.

EAST LEXINGTON, VIRGINIA. My favorite back road to Lexington from Goshen Pass is Turkey Hill Road, where one is more likely to encounter a passing tractor than a car. With a turn-off here, and a fork in the road there, drivers end up alongside the Maury River, behind VMI, before emerging opposite the East Lexington Grocery.

GREETINGS FROM KERRS CREEK. I worked in Lexington the summer after I graduated from Washington and Lee, and lived in Kerrs Creek, a collection of homes, barns, and a fire station, out on 60. My room in an old house there never got too hot under the shade of its companion old trees. Night was only illuminated by the moon and sometimes a passing car headlight, and the only sounds heard were those of the cows across the street, talking to one another. (Courtesy Lisa McCown.)

Eight

THE GIRLS' SCHOOLS

Higher education in Rockbridge County used to be strictly single-sex. Washington and Lee University, Virginia Military Institute, and Southern Virginia College now open their doors to everyone. Neighboring Sweet Briar College, Randolph-Macon Woman's College, Hollins University, and Mary Baldwin College have kept that part of their character intact. They are all worth at least one road trip, to introduce yourself and make new friends.

SOUTHERN SEMINARY, BUENA VISTA, POSTMARKED JUNE 6, 1924. Though the locals and the Lexington college boys still call it "Sem," the formerly all-female college on the hill is now co-ed and named Southern Virginia College. This building, Main Hall, was built in 1892 and originally served as a resort hotel. It is on the National Register of Historic Places and is a Virginia Historical Landmark.

FINE HORSES AND PRETTY GIRLS ARE A TRADITION AT S[O]
SEMINARY AND JUNIOR COLLEGE, BUENA VISTA, VIRG[INIA]

HORSES. Southern Virginia College offers an equine studies degree, as did its predecessor. The school maintains a stable of 30 horses with room left in the barn for students' horses. Many graduates go on to careers in fields such as horse show management and tack and leather goods.

MAIN HALL. The history of the college can be traced back to when it was Bowling Green Seminary, established in 1867. When it moved to the old resort hotel in Buena Vista, it was renamed Southern Seminary.

VISTA ADMINISTRATION BUILDING, MARY BALDWIN COLLEGE, STAUNTON, VA. "A beautiful example of colonial architecture, erected in 1842. Mary Baldwin is one of the oldest institutions of higher learning for women in the United States, and is known as 'The college with a background of culture and scholarship.' "

MARY BALDWIN INSTITUTE. The school was originally called Augusta Female Seminary. In 1895, it was renamed Mary Baldwin Seminary to honor a former student-turned-principal, who helped keep it open during the War Between the States. In 1916, the institution became Mary Baldwin Junior College, then, finally, Mary Baldwin College in 1923.

RANDOLPH-MACON WOMAN'S COLLEGE, LYNCHBURG, VA, POSTMARKED JANUARY 15, 1915. Unlike Sweet Briar, this college is in the thick of old Lynchburg. It was named for John Randolph of Roanoke and Senator Nathaniel Macon of Warrenton, North Carolina. The first students walked through the doors in 1893.

LANDSCAPE OF RANDOLPH-MACON, POSTMARKED MAY 25, 1910. My junior year I went to a formal here on a blind date set up by a friend from my freshman hall. (A tuxedo would have been a smart investment in my college years.) We sat in the prim parlors with our dates and drank grain punch and talked about how the real Virginia crept up on you every once in a while.

Sweet Briar College. SWEET BRIAR, Va.

SWEET BRIAR COLLEGE, SWEET BRIAR, VA, POSTMARKED APRIL 30, 1910. This school was named after the Sweet Briar rose; the 3,300-acre campus unfolds as beautifully. Part of the fun of coming here was seeing how many deer you could count frolicking on the road from the entrance to the security gate. The school is its own town, near Amherst, near Lynchburg, which makes it delightfully in the middle of nowhere.

Sweet Briar Lake.

SWEET BRIAR LAKE. The campus includes a lake that becomes inviting on a hot, late night. Once, at the beginning of a school year, some friends and I went to Sweet Briar to see the girls we hadn't seen in months. And we all swam in the lake and laid on the floating dock and stared at the stars, occasionally glancing in the direction security guards might come to order us out. But they never did, and we floated and talked for hours.

COLLEGE AND CAMPUS. It used to be great fun to slide down various hills on campus whenever it snowed. Of course, in particularly harsh winter storms, the heat in the buildings would go, so there wasn't always a refuge for wet sliders.

OLD SLAVE CABIN, SWEET BRIAR COLLEGE. Before Sweet Briar was a college, it was a plantation. Its slave cabin is still standing, and is now a farm tool museum on campus.

THE CHARLES L. COCKE MEMORIAL LIBRARY, HOLLINS COLLEGE, VA. "Hollins College, situated seven miles from the city of Roanoke. Oldest college for women in Virginia, founded by Charles Lewis Cocke. Began with Valley Union Seminary of 1842. An accredited liberal arts college with an endowment and board of trustees. A Southern college with a nation-wide patronage." This is no longer a library; it is an administration building. And Hollins College is no longer the name; it is now Hollins University.

HOLLINS COLLEGE, ROANOKE, VIRGINIA. It must have been my freshman year that I lost track of how many times I'd walked across this campus. It was long after freshman year that I saw it in daylight, since my friends and I often came for the late-night parties. I soon learned the best place to spend a day on campus was in a rocking chair on the porch of Main Hall.

THE QUAD. In my grandfather Montie Weaver's old papers, I came across a letter from the Dean of Hollins College, M. Estes Cocke, dated October 29, 1931. In it, Cocke offered him a teaching position at Hollins, based on a recommendation from the dean of the University of Virginia; my grandfather turned down the offer. By the end of 1931 he was signed with the Washington Senators baseball team, for whom he pitched in the World Series in 1933. His baseball nickname was "Prof."

THE LITTLE THEATER. My senior year I came here with my fraternity brothers to see a friend, who many of us had known for four years, perform her senior recital. Washington and Lee men think of the women at the girls' schools as alumni of a sort. We share spaces in each other's photo albums and stories.

Nine
The Road to Roanoke and Salem

One of my old journalism professors once told me when Rockbridge County residents say they are going to the "big town," they mean different things depending on where they live in the county. He said people in the north part head to Staunton; in the east they travel to Lynchburg, and in the southern portion, they go to Roanoke. I must admit I was part of the Roanoke contingent, drawn by the movie theater, the airport, and my friends at Hollins College (or some combination thereof). Surprisingly the drive there got shorter and more enjoyable as the years went by.

Touring along Highway No. 11 in Beautiful Virginia. If at all possible, you should avoid driving Interstate 81 for your trip to Roanoke. You'd miss the small towns that appear along the curves on Route 11. You'd miss a chance to see weather-beaten farmhouses you wish you could buy one day. You'd miss the restaurants, with homemade curtains, that still add up your bill for a warm ham biscuit on a pad and don't accept credit cards.

VIEWS OF BUCHANAN AND VICINITY, BUCHANAN, VA. Buchanan is one of those towns on Route 11 that is a preservationist's dream. New businesses are applying a bit of paint and brick to make a growing number of passers-by on Route 11 slow down. Ripening apple orchards also attract crowds with their blossoms and fruit.

NIGHT SCENE OF THE ELECTRIC STAR ON MILL MOUNTAIN. "Constructed on top of Mill Mountain 1,800 feet above sea level and 975 feet about the city. The largest man-made illuminated star in the world—88 1/2 feet in diameter, on a 100-foot structure—as tall as an eight-story office building. Nine rows (2,000 feet) of neon tubing."

BIRD'S-EYE VIEW OF ROANOKE FROM MILL MOUNTAIN. The Star City is home to just under 100,000 people. Its growth originally began after Norfolk and Western Railway made "Big Lick" a regional hub in the last century. Nearly everyone has heard stories of drivers who have pulled off the interstate to get a bite to eat or a tank of gas, and liked the city so much that they quit their jobs elsewhere and moved to Roanoke.

RESIDENTIAL SECTION AND MILL MOUNTAIN, SOUTH ROANOKE, POSTMARKED JULY 29, 1925. "Dear Aunt Bettie, I am canning pickles this morning. I now have 30 cans of cucumber pickles. We are getting ready to go to the District Aid Society meeting at Banner Ridge today. This is a very pleasant morning. I hope you are feeling better this morning. Was glad to hear yesterday that you were getting along nicely and hope you will continue to do so. Lovingly, your niece, Elizabeth Driver."

THE LOOP ON MILL MOUNTAIN. The first time I bought a car I took it up here for a drive with some Hollins friends. After a night-time spin around the mountain, we somehow talked and drove another 40 miles on the back roads before it was time to go home.

PET DEER AT CHILDREN'S ZOO ON MILL MOUNTAIN. "Children find this Virginia whitetail doe tame enough to pet. In the adjoining pen is the doe's mate." The zoo opened in 1952 (the Zoo Choo miniature train was installed in 1954). Today the 10-acre site is home to a Siberian tiger, red pandas, and Golden Lion tamarins.

Hotel Roanoke, Roanoke Virginia, a Modern 250-Room Version of an Old English Inn, Postmarked September 5, 1936. "Set in the midst of its own ten-acre park, in the heart of the city, a new 50 car garage connects directly with the lobby." The garage was built in 1931; the hotel itself was opened in 1882. It is listed in the National Register of Historic Places.

Aerial View of Roanoke, with Hotel Roanoke and Grounds in Center. In 1989, Norfolk and Southern Railway donated the financially troubled hotel to Virginia Tech. After an extensive fund-raising campaign, it was renovated and a conference center was added. "The Grand Old Lady on the Hill" re-opened in 1995.

TOP: **NORFOLK AND WESTERN RAILWAY PASSENGER STATION, ROANOKE.** *BOTTOM:* **SUNSET VIEW OF ROANOKE, VIRGINIA, WITH NORFOLK AND WESTERN TERMINAL IN CENTER.** The arrival of Norfolk and Western in what was called "Big Lick" spurred its growth and eventual transformation into Roanoke in 1882. The railroad's headquarters stayed in the city for a century, until a corporate merger began slowly taking jobs elsewhere.

BOTTOM: **MAIN STREET LOOKING WEST, SALEM.** James Simpson proclaimed the town of Salem in 1802 when he bought 13 acres of land on both sides of what is today Main Street. The general assembly granted Salem official town status in 1806.

LAKE SPRING PARK, SALEM. The greater Roanoke area has been called the "Great Springs Region of Virginia" for its large number of underground springs. A resort popped up at Lake Spring to accommodate visitors.

TWELVE O'CLOCK KNOB. Legend has it this mountain got its name because slaves on the Old Dixie Farm, west of Salem, could tell it was noon when the sun was directly over its peak.

THE COMMONS AND DORMITORIES, ROANOKE COLLEGE, SALEM, VA, NEAR ROANOKE. The institution that became Roanoke College was founded near Staunton in 1842. It moved to Salem in 1847, and was renamed Virginia Collegiate Institute; the present name took hold in 1853. The college's neat, green lawn, shadowed by the stately arms of trees likely as old as the campus, is particularly suited to memories of a day a good friend got his diploma.

ROANOKE COUNTY COURTHOUSE AND CONFEDERATE MONUMENT. The courthouse is now an academic building of Roanoke College; the main campus sits behind the building. The front has perhaps Salem's most dramatic view of the Blue Ridge, framed by buildings on either side of College Avenue.

ENTRANCE TO - "DIXIE CAVERNS" - SALEM, VA.

DIXIE CAVERNS, SALEM, VIRGINIA. Legend has it that a dog first discovered a hole at the top of a hill in 1920. Further investigation by curious farm boys yielded the discovery of the network of caverns beneath the surface. In 1922, Dixie Caverns was opened to tourists. It is located right off of Route 11, making it a likely stop for travelers between Salem and Ironto.

"THE MAGIC MIRROR"
DIXIE CAVERNS
Salem, Va.

81

CARVIN'S COVE LAKE, A GREAT PLACE FOR WATER SPORTS, NEAR ROANOKE. Picnics were made for Carvin's Cove, a lake a short drive from Hollins. Countless shades of wildflowers grow on the drive there; the curviness of the road ensures you'll go slow enough to see those shades for yourself.

Ten

The Road to the Homestead

College students often entertain notions of grandeur, whether it be present or implied by their belief in the future. We dressed in our best starched white shirts and pressed pants to comment on the good life at cocktail parties. The Homestead was the one other nearby institution where such grand impressions would fly. It is more realistic to consider the resort as a treat for lodgers and diners to savor occasionally and then go back to the more simple pleasures.

Front Stream, Virginia, Hot Springs. Route 39 is one path to Hot Springs and the Homestead. The view along the way includes the occasional tall white farmhouse surrounded by a white fence, then a stretch of broad fields, then a river alongside the road. In winter, its ice often seems to creep up onto the road where travelers head to the resort to ski or skate.

C. & O. Hospital and Bluffs, Clifton Forge, Va.

C&O HOSPITAL AND BLUFFS, CLIFTON FORGE, VIRGINIA. After the War Between the States, the Chesapeake and Ohio Railway chose to put its new depot in Clifton Forge. This brought rapid economic growth, and Clifton Forge received its city charter in 1906. Visitors to Clifton Forge can drop by its neighbor town, Selma, before going on to Covington, then Hot Springs.

BIRD'S-EYE VIEW OF COVINGTON, VA.

BIRD'S-EYE VIEW OF COVINGTON, VIRGINIA. The town is the county seat of Allegheny County, and is named for a hero in the War of 1812, General Leonard Covington. Today, its main industry is a paper mill, which produces 2,500 tons of bleached paper and paperboard each day for use in products ranging from folding cartons to baseball cards. After you get off Interstate 64, you drive through the town to eventually approach Hot Springs from the south.

MAIN ENTRANCE OF THE HOMESTEAD HOTEL. Some people consider the Homestead, located in the Allegheny Mountains, the finest of the high mountain spas. The first resort at the location was built in 1766; its popularity picked up quite a bit in the next century thanks to improved transportation and word-of-mouth that the hot springs could ease the pains of the infirm, and the mountain air could reinvigorate those for whom the heat of flat land in the summer was too much to take.

My Address is the Homestead, Postmarked March 3, 1905. A new hotel constructed of brick was opened in 1902 after a fire the year earlier destroyed the first one, which was made of wood. The resort's spa, casino, and cottage row survived the blaze intact. The hotel was designated a National Historic Landmark in 1991.

Full House. A new tower was added to the hotel in 1921. Now it is the symbol of the Homestead and the first thing visitors see when they arrive in Hot Springs. During World War II, the state department used the resort as an internment site for Japanese diplomats and their families after the bombing of Pearl Harbor.

Porte Cochere of Homestead Hotel, Hot Springs, Va.

PORTE COCHERE. The resort claims many sitting presidents as visitors, including William Taft, Woodrow Wilson, Warren Harding, Calvin Coolidge, and Lyndon Johnson. Richard Nixon and Gerald Ford came as vice presidents, Franklin Roosevelt as governor of New York, and Ronald Reagan and Dwight Eisenhower as private citizens.

LOBBY, POSTMARKED JANUARY 31, 1928. The Great Hall measures 22.5 feet in height, 211 feet in length, and 42 feet in width. Visitors and guests who relax in the wicker chairs reading the *New York Times* can take tea at four o'clock from the uniformed servants.

THE DINING ROOM, POSTMARKED MAY 29, 1932. My mother and father took me to the Homestead for a birthday dinner when I turned 22, which was the day before my college graduation. And afterward my mother and I danced to "Happy Birthday" in the ballroom. It was the best birthday I've had yet.

ONE OF THE VERANDAS. There is something to be said about the power of a good rocking chair and a mountain view to relax a weary traveler. It is also a good place to sit a spell after a good meal. My father and I rocked on these chairs after my birthday dinner. Something about that moment made me realize there were many good things in life ahead.

***Top:* Soda Spring, South Wing and Tower. *Bottom:* Evergreen Gardens.** The grounds of the Homestead are meticulously kept, as are the golf courses, the first of which was built in 1892. It sports the oldest first tee in continuous use in the United States.

89

A Mountain Cottage, Hot Springs, Virginia. The luxury of the Homestead has never been a reflection of the life lead by everyone in that area of Virginia. Perhaps these people were just as proud as the proper gentlemen and ladies who spent their leisure at the resort.

Daniel Boone's Cabin near Hot Springs, VA, Postmarked February 18, 1911. Records from this time indicate the cabin, one mile from the Homestead, was converted into a luncheon house, featuring "teas, luncheons, dinners, and waffle parties." It also featured long distance telephone service and open-air dancing.

Eleven

Papa's Footsteps

My grandfather, Montie Weaver (Papa), would often tell me stories about how he and his father would pass through Lexington on a horse when he was a boy. They lived just over the North Carolina border in Helton; relatives were spread out across southwest Virginia, including one in the perfectly named little town of Mouth of Wilson. Papa spent time as an adult in Emory and Charlottesville, making his mark.

WILEY HALL, ADMINISTRATION BUILDING, EMORY AND HENRY COLLEGE, EMORY, VIRGINIA, NEAR ABINGDON. This little school was founded in 1836; it claims to be the oldest institution of higher education in Southwest Virginia. It is literally the only thing at its exit off Interstate 81, just a few miles from the Tennessee border. No stores or gas stations clutter the half mile to the school's gates.

EMORY AND HENRY ACADEMY, EMORY, POSTMARKED OCTOBER 20, 1911. Papa got his degree in mathematics from E&H in 1927. He paid his $400 annual tuition with money he earned playing summer baseball in the North Carolina leagues. The school considered him to be perhaps the best baseball player ever to attend.

SPRING HOUSE AND CAMPUS, EMORY AND HENRY COLLEGE, POSTMARKED MARCH 23, 1910. "Hello Novella: Well I am back at Emory, came yesterday evening and had an exam today. Have never heard a word from you. Yet wonder what is the matter . . ."

INAUGURATION DAY, U. OF VA. CHARLOTTESVILLE, VIRGINIA. Thomas Jefferson founded the University of Virginia in 1819. He designed an "academical village" as its campus. In 1976, the American Institute of Architects deemed that campus the most outstanding architectural achievement in the first 200 years of American history.

UNIVERSITY OF VIRGINIA FROM THE AIR. Papa got his master of science degree from the University of Virginia in 1929; he had turned down the Rhodes Scholarship in 1928 to finish his studies. He continued to play baseball in his summers and turned pro before he enrolled at UVa. After he graduated, he stayed on as an instructor of analytic geometry, but he left in 1930 to play baseball again.

NORTH VIEW OF THE ROTUNDA, UNIVERSITY OF VIRGINIA, CHARLOTTESVILLE, VIRGINIA. A fire destroyed the original rotunda, but the university restored it and preserved it as the centerpiece of the university. On the lawn in front, students study and play frisbee.

Twelve

LANDMARKS

Every Virginian has certain landmarks he or she shows off to friends or visits with a picnic in tow. Some are found in out-of-date, dog-eared guidebooks; others come as personal recommendations from other travelers. These landmarks aren't very fancy, but that hardly matters.

THE OLD WYTHE SHOT TOWER. "This tower, one of Virginia's oldest landmarks, was built about 1820 by Thomas Jackson to manufacture shot. It is 20 feet square, 75 feet high, with walls 2 and a half feet thick, and in shape resembles a fortress. It is said that both Daniel Boone and Thomas Jefferson often visited there and that ammunition from the tower was used in the War of 1812. Here on New River, before the Revolution, a ferry was established, later called Jackson's Ferry, that was in operation until 1930." When you drive north to Virginia, the shot tower is a marker, just after the border, that indicates you are in home territory.

HUMPBACK BRIDGE ON MIDLAND TRAIL, NEAR COVINGTON, POSTMARKED DECEMBER 29, 1953. "One of the most interesting things that catches the eye of the tourists, as they pass through the Allegheny Mountains of Virginia, is the Old Humpback Bridge, which is located near Covington, Va. on the Midland Trail, from Hot Springs, Va. to White Sulphur. It was built in the year 1842 by the pioneers who settled in Allegheny County, and stands today a memorial to their wonderful skill in bridge building. This bridge is constructed of hewn oak, and is held together by heavy locust pins. Thousands of automobiles and heavy trucks pass over this bridge yearly, and it promises to last many more years, as it is considered to be one of the strongest wooden bridges in Allegheny County."

THE OLD LINCOLN HOMESTEAD, NEAR HARRISONBURG, VIRGINIA. President Abraham Lincoln's grandfather and namesake was born in this house on February 12, 1809. Parts of the extended Lincoln family remained in the area, in Lacey Spring, on a farm near Linville Creek in Rockingham County.

ENTRANCE TO WEYERS CAVE, GROTTOES, VIRGINIA, THE MOST WONDERFUL CAVERN IN THE WORLD. The bottom postcard is postmarked August 27, 1923. According to legend and a tourist brochure, a boy named Bernard Weyer stumbled upon the caverns in 1804 while searching for a raccoon trap. During the War Between the States, "Stonewall" Jackson quartered his troops in the caverns; some of them even wrote their names on the walls. Later in the century, the invention of electric lighting allowed for elaborate balls to be staged in the 5,000-square-foot "Grand Ballroom" cavern.

97

FRONT VIEW OF ASH LAWN, HOME OF JAMES MONROE, POSTMARKED OCTOBER 11, 1937.
" 'Ash Lawn,' home of James Monroe, Revolutionary hero, signer of the Louisiana Purchase, author of the Monroe Doctrine, and fifth President of the United States, was planned for him by his friend and neighbor Thomas Jefferson and built in 1798, within sight of Monticello and about 4 miles from Charlottesville, Va."

TOMB OF PRESIDENT JAMES MONROE (HOLLYWOOD), RICHMOND, VIRGINIA, POSTMARKED JULY 2, 1911. "Situated on 'President's Hill' Hollywood Cemetery. Through the open mullions of this mortuary monument may be seen the marble sarcophagus covering the remains of James Monroe, twice governor of Virginia, fifth President of the United States (1817–1824) and author of the Monroe Doctrine. Died in New York City in 1831 and was there buried. In 1858, however, his remains were disinterred and removed to their present resting place. Near by is the grave of President John Tyler."

MONTICELLO, HOME OF THOMAS JEFFERSON, NEAR CHARLOTTESVILLE, VIRGINIA. "At Charlottesville, Monticello, designed and built by Jefferson as his life-time home. Here Jefferson received his good friend, Lafayette. From Monticello's portico he watched the infant University of Virginia, child of his mature brain, take life, and at Monticello he lies buried beneath a simple granite shaft on which is inscribed: 'Here was buried Thomas Jefferson, Author of the Declaration of American Independence, of the Statute of Virginia for Religious Freedom, and Father of the University of Virginia.' "

NORTH TERRACE BUILDING - MONTICELLO

MICHIE TAVERN, CHARLOTTESVILLE, VIRGINIA. "Michie Tavern, once the home of Patrick Henry, was built in 1735. It is located 1 mile southeast from Charlottesville, Virginia, on the Monticello Road. This historic old tavern has been restored and is furnished from Revolutionary and Colonial periods, and is open to the public."

CYCLOPEAN TOWERS, MT. SOLON, VIRGINIA. "These Colossal Natural Towers, seven in number, rise perpendicularly for over 100 feet above the surrounding plain. A tunnel, large enough for an automobile, runs through the base of one of the towers."

Thirteen

LEE AND WASHINGTON

I think people who live in Virginia are predisposed to be curious about history. That disposition made me seek out the footprints of the men for whom my alma mater was named. Their lives are noted everywhere from black, gilt-charactered signs placed on the side of roads, to marble statues privy to echoed conversations in great halls, to their dignified homes, where no detail lacks an accompanying anecdote.

STRATFORD HALL, WESTMORELAND COUNTY, VIRGINIA, POSTMARKED OCTOBER 12, 1936.
"Stratford Hall, about 48 miles from Fredericksburg on King's Highway. Richard Henry Lee, Frances Lightfoot Lee, Light Horse Harry Lee, and General Robert E. Lee were born here. With its eight chimneys, its great high-ceilings hall, its two wings, its English basement, it is unlike any other home in America."

"ARLINGTON HOUSE ESTATE."

The lands comprising this estate or property are a part of an original grant of 6,000 acres from William Berkeley, Governor of Virginia to Robert Howsen, in October 1669, in consideration of the said Howsen having transported a number of settlers into the colony. In the same year Howsen conveyed these lands to John Alexander, the consideration being six hogsheads of tobacco; and on December 25, 1778, Gerald Alexander, to whom the property had descended, conveyed the Arlington Tract about 1,100 acres to John Parke Custis, the consideration named being 1,100 pounds in Virginia currency.

John Parke Custis was the son of Martha Washington by her first marriage. He was aide-de-camp to Washington during the Revolution, and upon his death, November 5, 1781, of camp fever contracted at Yorktown, Washington adopted his two youngest children—George Washington Parke Custis and Eleanor Parke Custis.

George Washington Parke Custis, who inherited the Arlington Estate from his father, was a member of Washington's family until the death of Washington in 1799, and soon after removed to Arlington where he resided until his death, October 10, 1857.

By his will, bearing date of March 26, 1855, he devised the "Arlington House Estate" to his daughter and only child, Mary Ann Randolph Lee, wife of Lieut. Col. Robert E. Lee, U. S. Army, for her use and benefit during her natural life, and on her death to his eldest grandson, George Washington Custis Lee, to him and his heirs forever.

By an executive order by the President of the United States dated January 6, 1864, the entire tract of 1,100 acres, more or less, was "selected for Government use for war, military, charitable, and educational purposes," under the provisions of the Acts of Congress of June 7, 1862, and February 6, 1863. By the same order it was directed that the property be sold to meet the payment of $92 07, direct taxes due thereon. This was done January 11, 1864, and the property was bid in for the United States for the sum of $26,800.00. Mrs. Lee, having died in 1873, legal proceedings contesting the legality of the tax sale were instituted by George Washington Custis Lee, as heir under the will of his grandfather, George Washington Parke Custis. The cause was heard in the United States Circuit Court for the Eastern District of Virginia, and verdict rendered in his favor, which, upon appeal, was affirmed by the decision of the Supreme Court of the United States, December 4, 1882.

Congress, by act of March 3, 1883, appropriated the sum of $150,000 for the purchase of this property and on March 31, 1883, George Washington Custis Lee conveyed to the United States by deed the title to the property in question for the sum appropriated.

Lee Monument, Richmond, Virginia, Dated August 9, 1907. Jean Antoine Mercie's statue of Lee was dedicated on May 29, 1890. It is set among other statues of noted Virginians that mark the historic Monument Avenue.

Boyhood Home of Robert E. Lee, Alexandria, Virginia. The Lee-Jackson Foundation, which owns this building, has decorated it with period pieces to simulate the look of Lee's family's home during his childhood. It is said that George Washington and Marquis de Lafayette often visited the house.

VALENTINE'S STUDIO (NO. 803 S. LEIGH STREET) RICHMOND, POSTMARKED OCTOBER 22, 1912. "Edward L. Valentine, the celebrated sculptor of whom Virginia is so justly proud, is here shown in his studio surrounded by models, casts, art works, etc. The bust in the foreground is a study of Robt. E. Lee, executed in connection with the statue which Mr. Valentine designed for placement in 'Statuary Hall' at Washington. Here have been designed the incomparable recumbent statue of Lee, at Lexington, the statue of Jefferson, in the hotel of that name, and of Jefferson Davis on Monument Ave., as well as other noted works of art too numerous to mention here."

HOUDON'S STATUE OF WASHINGTON (STATE CAPITOL), RICHMOND, VA. "Erected in the rotunda of the State Capitol in 1796; has been pronounced one of the most priceless pieces of marble in the world. It was executed in Paris, after a personal visit paid by the sculptor to his subject, at Mount Vernon. An intimate friend of the 'Father of his Country' has said 'Look at this statue on a level with it, and you may well think you are beholding Washington himself.' A replica has been contributed by Virginia to the 'Hall of Fame' at the National Capitol."

WASHINGTON'S MANSION, MOUNT VERNON, VIRGINIA. George Washington acquired Mount Vernon from his half-brother's widow in 1754. His father had built the original house on the property, which was remodeled by the half brother and further enlarged by George Washington. He lived here with his wife, Martha, until his death in 1799. She died in 1802.

106

TOMB OF WASHINGTON. "The Tomb of Washington at Mt. Vernon, Va., is a plain brick structure overgrown with ivy. On a slab over the arched gateway is inscribed, 'Within this inclosure rest the remains of Gen. George Washington.' It is a spot sacred to all Americans, a shrine visited annually by thousands. It is the custom for the officers and crew of all vessels to stand at attention, and for the ship's bell to be tolled in passing Mt. Vernon on the Potomac, out of reverence for the last resting place of Washington. Its preservation is due to the Mt. Vernon Ladies Association, who by patriotic courage, acquired the estate by purchase in 1860."

CHRIST CHURCH, ALEXANDRIA. Washington was a vestryman in the district that included Christ Church; he and the 11 other elected church officials supported the church after the American Revolution put an end to taxes levied on behalf of the church. Construction of Christ Church's main building began in 1767, and was completed in 1773. Robert E. Lee attended the church whenever he was in the area; he was confirmed there.

Fourteen

GREETINGS FROM VIRGINIA

No Virginia postcards proselytize for the state and the Shenandoah Valley as well as landscape images. It seems every nook and cranny of undeveloped Virginia has commemorative postcards to be set alongside the developed areas. I bet both get equal attention.

APPLE BLOSSOM TIME IN VIRGINIA. Each year the town of Winchester hosts the Apple Blossom Festival. Celebrities are called in to be grand marshals of the parade through town, which is only the tip of the iceberg for the activities. The festival also includes a visit from the circus and a flying contest at the regional airport.

FISHING IN GEORGE WASHINGTON NATIONAL FOREST, VIRGINIA. "The Forest Service, with jurisdiction over a million acres of public owned forest lands extending from Winchester to Covington, Virginia on both sides of U.S. 11, are each year planting thousands of fish and supplying the streams with food and other protection." In 1917 the federal government bought three tracts of land and combined them into the Shenandoah National Forest, which was later renamed for George Washington.

TOP: BLUE RIDGE MOUNTAINS, POSTMARKED MARCH 22, 1918. *BOTTOM:* SUNRISE OVER LURAY, VIRGINIA, BLUE RIDGE MOUNTAINS IN BACKGROUND. The land gets flatter on the drive north on Interstate 81 and Interstate 66 to Washington, though the mountains are never really out of view. Drivers pass many signs advertising the best of Virginia's caverns and the weavers who sell their wares at the cavern gift shops. Several times a year Confederate and Yankee reenactors marchers dot these rolling hills, going through the motions of history.

JAMES RIVER PASSING THROUGH BLUE RIDGE MOUNTAINS. The river runs 450 miles from near the border with West Virginia to the Chesapeake Bay. Its upper reaches contain numerous fisheries; its falls in Richmond powered flour and paper mills and fed iron works. The James also became an avenue of transportation, especially with the addition of locks and canals.

SCENE ON JAMES RIVER, NEAR BUENA VISTA, IN SHENANDOAH VALLEY. Occasionally James River fishermen will reel in a Yankee musket or sword as their catch. Many of those fishermen stand on the flat lanes carved into the side of hills that line the banks of the river, where railroad tracks used to lay.

NARROWS OF NEW RIVER, VIRGINIA, POSTMARKED APRIL 7, 1908. When I was growing up, my family would spend our summer vacations at a cabin on the New River, just across the state line in Warrensville, North Carolina. My brother Randy and I would drift on innertubes down the New River for what seemed like a long way, but was probably about half a mile. Before the river got too wide, our parents would retrieve us near the bridge where we liked to skip rocks, and then we would walk back to the cabin and do it again.

A Peaceful Scene in the Southern Appalachian Mountains. One of the first things that struck me after moving to Virginia was the color green. That color, in particular, seemed to glow ever so slightly, especially when clouds obscured the sun. It is a green that encourages pause.

SCENE ON STATE HIGHWAY NEAR HARRISONBURG, IN SHENANDOAH VALLEY. In the city we often get too wrapped up in conducting our lives in terms of speed. In rural Virginia, it is immediately apparent that kind of lifestyle is a silly notion. Who needs a freeway when drivers can get more quality thinking done on a dirt road?

115

A Picturesque View of Peaks of Otter, Virginia. The bottom postcard is postmarked August 17, 1936. This twin-peaked mountain in Bedford County is in the background of quite a bit of southwest Virginia. Camping and cabins are available for travelers on the Blue Ridge Parkway. Little stores offer the dishes and towels to make your home look just like one off a gravel road from the parkway.

STATE HIGHWAY AND MOUNTAIN SCENE NEAR STAUNTON, IN THE SHENANDOAH VALLEY. The Cherokee Indians who lived here a thousand years ago called the mountains "the Blue Wall." The range is the eastern-most ridge of the southern Appalachian Mountains. There are approximately 130 species of trees, 1,400 species of flowering herbs, and 350 species of mosses and related plants to be found there.

APPALACHIAN SCENIC HIGHWAY, CROSSING IN THE BLUE RIDGE MOUNTAINS. This scene reminds me of the eastern side of Rockbridge County, where the roads wind and twist their way to Amherst County. Past the small town of Big Island, in a place called Boonsboro, my maternal grandfather, Walter Meriwether's grandparents, and other relatives are buried in the Meriwether plot at the Trinity Methodist Church.

VIRGINIA WHEAT FIELD, ROCKBRIDGE COUNTY. Pictured are freshly cut bales of hay used to line the fields adjacent to Muddy Lane, my favorite walking road in Rockbridge County. Old barns dot these fields as well; they're never far from a house with sunflowers in the yard or a chuckling creek.

A ROAD IN THE BLUE RIDGE MOUNTAINS OF VIRGINIA. Dogs are the true owners of the back roads; they greet passing cars and accompany them as far as they can run. The pursuers are in luck if there is a wild blueberry bush nearby where the cars stop; then they can collect a few pats and kind words as payment for allowing the pickers to take handfuls of fruit home.

ONE OF THE NUMEROUS WATERFALLS IN THE BLUE RIDGE MOUNTAINS, POSTMARKED JUNE 4, 1937. "Dear Murrell—at Staunton now. Just mailed card that I wrote in Lexington. Oh dear the bus is going to start again. The rest of this will be scribbled. I'm very sleepy and feel very dirty . . . Did you write to your mother yet? Please do—she might worry, although I don't see why she should worry about a goose like you . . . Love, Billy." Murrell was my aunt, Vicki Meriwether's father, and she gave me this card.

ONE OF THE MANY PROMISING FISHING HOLES, SHENANDOAH VALLEY. One of the best things about going to school in Virginia is the increased likelihood you can take some of your classes outside. Physical education classes, like canoeing, seem like a natural addition to the curriculum, particularly when it's hot outside. Canoers can stop along a cleared part of the riverbank and walk to a nearby pool fed by a waterfall.

CAMP LIFE IN THE HEART OF THE MOUNTAINS, POSTMARKED AUGUST 17, 1936. "Dear P.M., Arrived o.k. Am feeling fine, after having palpitations of the heart from cars dashing around the mountains in front of me, O Boy, O Boy, it's a thrill."

Fifteen

LORE

We all accumulate images that romanticize our idea of Virginia. We dream of the symbols of state pride and heritage. These are the postcards that are the most difficult to collect, because they are selected on the basis of personal attachment, not necessarily to fill missing pieces in a collection of a certain printer or subject. These postcards make me stop and think about the special adjective, "Virginian."

HUMAN CONFEDERATE FLAG, POSTMARKED JUNE 2, 1911. "One of the most pleasing as well as spectacular features of the great re-union of C.S.A. veterans in May-June 1907 for the purpose of participating in the exercises incident to the unveiling of the Jeb Stuart and Jefferson Davis Monuments, was the arrangement and costuming of 600 school children in the form and colors of a Confederate battle flag. The children occupied a stand within the Lee Monument enclosure and aroused the greatest enthusiasm by their singing of 'Dixie' and other Southern airs."

WRECK OF THE "OLD 97," SEPTEMBER 27, 1903, DANVILLE, VIRGINIA. No bluegrass compilation is worth its vinyl if it doesn't include "The Wreck of the Old 97." It is arguably the most famous railroad disaster in Virginia history. As the song says, the Old 97 lost its airbrake on a 3-mile grade stretch of rail and jumped the tracks.

A TYPICAL MOONSHINE STILL IN THE HEART OF THE MOUNTAINS. I never found a still, though there was always word of them in the newspaper. A friend did give me a sip of apple moonshine once, the likes of which could explode your mouth.

Rapid Transit at Virginia Hot Springs. All around, the pondering students and intellectuals are people who do the hard work, as it has been done for generations. It's a thought to keep in mind during "tough days."

A Bright and Glad New Year, Postmarked December 22, 1909. "This is to wish you a Merry Christmas and a Happy New Year . . . Richmond is getting to be very musical. I wish you could come to see me."

123

A VIRGINIA MARKET CART. When I was little, my family used to drive through all sorts of small towns in Virginia, looking through the shops for furniture and other things for our home. On occasion, they would buy a chair, wedge it into the back seat, and I would fall asleep in it on the way home.

SHIRLEY, ON THE JAMES RIVER, VIRGINIA. DATED DECEMBER 26, 1906 BY "UNCLE WILL." Maybe I'll be able to buy my parents a house like Shirley one day. It would be filled with all their favorite antiques, and I would visit often.

WINTER. When I think of the happily-ever-after, I imagine myself in an old, warm farmhouse with my family, somewhere around Lexington. I would be sitting at my old desk, working on a story or a book, in the silence that comes with a snowstorm. I would wonder why anyone would choose to leave this peace for the outside world.

HOME, POSTMARKED APRIL 16, 1907. "Our Southern house in the green fields of Virginia. Lizzie."

125

VIRGINIA.

The roses nowhere bloom so white
 As in Virginia;
The sunshine nowhere shines so bright
 As in Virginia;
The birds sing nowhere quite so sweet
 And nowhere hearts so lightly beat.
For Heaven and Earth both seem to meet
 Down in Virginia.

The days are never quite so long
 As in Virginia;
Nor quite so filled with happy song
 As in Virginia;
And when my time has come to die,
 Just take me back and let me lie
Close to the Blue Ridge Mountains high
 Down in Virginia.

 There is nowhere a land so fair
 As in Virginia;
 So full of song, so free of care,
 As in Virginia;
 And I believe that happy land
 The Lord's prepared for mortal man
 Is built exactly on the plan
 Of Old Virginia.

INDEX

Abingdon 100
Alpha Tau Omega 36
Ann Smith Academy 21
Arlington House 102
Ash Lawn 98
Blue Ridge Parkway 51
Bonaparte, Joseph 56
Boone, Daniel 90
Boonsboro 117
Buchanan 72
Buena Vista 49-52, 63, 64
 Post Office 52
 21st Street 50
Carnegie, Andrew 47
Carvin's Cove 82
Cemetery 26
Central Hotel 22
Charlottesville 93, 94, 98, 99
Chi Psi fraternity 21
Christ Church, Alexandria 108
Clifton Forge 84
Coffey, W.W. 24
Covington 84, 95
Cyclopean Towers 100
Dixie Caverns 81
Dutch Inn 19
Emory and Henry College 31, 91, 92
George Washington National Forest 110
Goshen Pass 59-62
Grace Church 17
Grottoes 97
High School 97

Hollins College (University) 69-71
Hollywood Cemetery 98
Homestead 85-89
 Dining Room 88
 Evergreen Gardens 89
 Golf Courses 89
 Lobby 87
 Main Entrance 85
 Porte Cochere 87
 Soda Spring 89
 Veranda 88
Hot Springs 83-90
Hotel Roanoke 76
Houdon Statue, Richmond 105
Human Confederate Flag 121
Humpback Bridge 95
Jackson, Thomas J. "Stonewall" 18, 25-28, 97
James River 112, 113, 124
Jefferson, Thomas 54, 57, 93, 98
Kappa Alpha Order 36
Kerrs Creek 62
Lake Spring Park 79
Lee, Robert E. 11-14, 23, 37, 38, 104
Lee Chapel 11-14, 41
Lee Monument, Richmond 103
Letcher Avenue 36
Lexington Triad 36
Lincoln Homestead 96
Liquid Lunch 22
Luray 111
Main Street 15, 16
Mary Baldwin College 65

Mason's Creek 82
Maury, Commodore Matthew 59, 60
Maury River (North) 51, 59, 62
Mayflower Hotel 24
McCampbell Inn 22
Meriwether, Walter H., Sr. 117
Meriwether, Vicki 119
Michie Tavern 99
Miley, Michael 13
Mill Mountain 73-75
Mill Mountain Star 73
Mill Mountain Zoo 75
Monacan Indians 53
Monroe, James 98
Monticello 99
Mount Vernon 11, 106, 107
Natural Bridge 53-58
 "Bridge of Years" 58
 Cedar Creek Trail 54
 "Drama of Creation" 54
 Historical Markers 54
 Hotel 55
 Salt Petre Cave 57
 Swimming Pool 55
 Lost River 57
 Motor Lodge 56
New River 113
Norfolk and Western Railway 77
Nunn, Phil 23
"Old Dixie" 23
Peaks of Otter 116
Peale, Charles Willson 13
Pine, Theodore 13
Post Office 21
Presbyterian Church 18
Robinson, John 44
Rockbridge County Court House 24
R.E. Lee Hotel 20
R.E. Lee Memorial Church 17
Randolph-Macon Woman's College 66
Richmond 8, 98, 103-105, 123
Roanoke 71-77
Roanoke College 80
Roanoke River 79
Salem 78-81
Shirley 124
Sigma Nu 36
Stonewall Jackson Hospital 25
Stonewall Jackson House 25
Southern Seminary 52, 63, 64
Southern Virginia College 63, 64
Stratford Hall 101

Sweet Briar College 67, 68
Train 22
Trinity Methodist Church 18
Tucker-Davidson House 25
Twelve O'Clock Knob 79
University of Virginia 93, 94
Valentine, Edward 12, 26, 102
Virginia Military Institute 27-36
 Athletic Field 36
 Butts Manuel 32
 Cadet June Final Dress Parade 32
 Cavalry 27
 Ezekiel Statue 29
 Footbridge 36
 Gate 35
 Houdon Statue 34
 Jackson Memorial Hall 28
 Library (Preston) 31
 Little Sorrel 28
 Marshall, George C. 30
 Mess Hall 31
 Stonewall Jackson Marches 29
Washington, George 54, 105-108
Washington and Lee University 37-48
 Liberty Hall 37
 Augusta Academy 37
 "Back to Washington and Lee" 48
 Colonnade 38, 40-42, 44, 46
 Dormitories 39, 46
 Footbridge 43
 Lee House 38
 Lee-Jackson House 42
 Library 46, 47
 Newcomb Hall 38, 47
 Reeves Center 44
 Reid Hall 39, 46
 Robinson Hall 38
 Tucker Hall 38, 45
 Wilson Athletic Field 43
 World War Memorial Gate 41
 Weaver, Montie M. 31, 70, 91, 93
Weaver, Randy 113
Weyer's Cave 97
Winchester 110
"Wreck of the Old 97" 122
Wythe Shot Tower 96